HOW TO MAKE MISTAKES ON PURPOSE

Sabotage Digital Convention.
Upgrade Your
HUMAN
BRAIN.

PECULIAR NEVER HAPPEN BRICOLAGE NOT_NOW

FIRST_PANCAKES MITFORDIANA

ISHKABIBBLE MILK_PAINT_RECI
 PES KILLED DREAMS
 DEFERRED

SAVE_IF_FUTURE WAX PAINT LARRY DAVID? lauriemacbookpro

ANCHOVIES

Hachette Go, an imprint of Hachette Books
Hachette Book Group
1290 Avenue of the Americas
New York, NY 10104
HachetteGo.com
Facebook.com/HachetteGo
Instagram.com/HachetteGo

First Edition: November 2021

Hachette Books is a division of Hachette Book Group, Inc.

The Hachette Go and Hachette Books name and logos are trademarks of Hachette Book Group, Inc.

The publisher is not responsible for websites (or their content) that are not owned by the publisher.

Print book interior design by Laurie Rosenwald

Library of Congress Control Number: 2021019792

ISBNs: 9780306925160 (hardcover), 9780306925153 (ebook)

Printed in the United States of America

WOR

10 9 8 7 6 5 4 3 2 1

how to

laurie
rosenwald

make
mistakes
on
purpose

BRING CHAOS TO YOUR ORDER

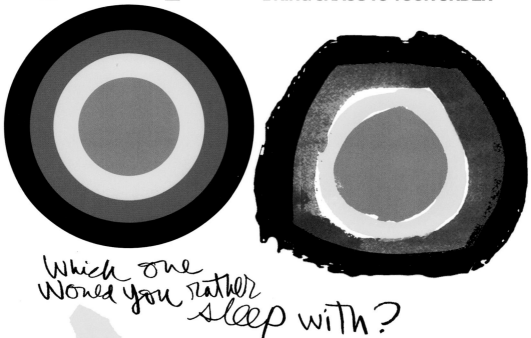

which one
would you rather
sleep with?

other books

Written and Illustrated by Laurie Rosenwald

***All the Wrong People Have Self-Esteem**, an inappropriate
book for young ladies, and frankly, anybody else*

***And to Name but Just a Few: Red, Yellow, Green, Blue**, named
one of the year's best books by *Scholastic Parent and Child**

***New York Notebook**, a hyperillustrated, overdesigned
guidebook, sketchbook, and blank book all
mushed up together*

These August Names, Once Dropped,
Shall Not Bounce upon This Earth:

David Sedaris, *generous friend, I Pinch Your Claws.*

Douglas Coupland, *who noticed.*

David Bowie, *who bought me that cheeseburger*
upon which I have been dining out since 1979.

Table of

Contents

In 2010, Kirsty Young interviewed writer Fay Weldon for the sublime BBC show "Desert Island Discs."

Weldon: I find it difficult to live by my principles.

BBC: Do you try?
Weldon:

NO.

A human. My favorite kind of bean.

FiRst we Thought No INTRo would be best. more in the SPIRIT OF How TO MAKE MISTAKES ON PURPOSE, but Now we've changed OUR MINDS.

THE INTRO ↓

For the past thirty-five years, I've been holding a super fun and popular workshop called "How to Make Mistakes on Purpose." Everyone who hears that says, "Oh, I'm already quite good at that." Ah, if this were only true. It's not. You know what you're doing! I'll bet you are highly skilled. When you get good at something, you repeat it. It's so very satisfying to know it will turn out just right.

"What's wrong with that?"

Everything.

Because shared tastes, technologies, and similar experiences equal no surprises.

Ladies and Gentlemen, I give you … a Guide to Getting Lost.

How to Make Mistakes on Purpose is not what you think it is. It's not that adorable psychopath you once dated, your home pickling phase, or baby's first tattoo … these may be spectacularly regrettable, but not mistakes on purpose. And it's not about accepting or learning from your mistakes so that you'll do better next time. The idea is to *really make mistakes on purpose.*

Mistakes help people create truly original things. Mistakes help you get unstuck when you're stuck.

That is what HTMMOP is for.

It could be an invention that saves lives or a new dessert. It could be a lucrative investment or a road trip. It could help you with your taxes, find an apartment, pick up a check, or pick up a chick. Can I say that? No? Well, I don't care.

When you surprise yourself, you surprise others. And that is priceless in a world where everything seems to have been done.

Don't you want to be more fulfilled, productive, or creative? Don't you want to generate new ideas?

Also, it's just plain fun.

When your life's work is more fun than fun, then you have real success.

For me, what I do for ten hours every day is more enjoyable than playing games, vacations, shopping, food, or sex. I am lucky. I get to draw, paint, write, and create, and sometimes I even get paid for it! Nothing in the world makes me happier. You can take the puppies away. I am my own puppy.

That may be the pivotal take-away here. After all, nobody can sunbathe, eat meringues, and have fantastic sex for eight hours every single day. And if you can, well ... why are you reading a book?

But ... this is the point where we need to distinguish the this from the that. Be honest. If you can indeed take a risk without causing harm to yourself or others, and assuming this is our precious, one-and-only brief shot at life, living it as a stimulating, entertaining adventure clearly beats enduring it as an obligation. And if you must be a pathetic wage slave, let it be as a last resort.

I take it as a given that most things we humans do are utterly indefensible. This, I relish and will defend until my last breath. My differentness is my outstanding strength. I treasure my outsider status. I brought myself up. Alone. I have never had to conform. If you want to be your even uniquier genuinier self, I'm your girl. Yes, I know those are not words, and I don't give a fig. I am passionate about the potentiality that comes from human imperfection. I have given my life to helping people surprise themselves.

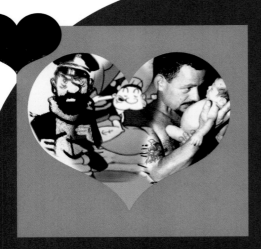

Underneath your tattoos you're still a mainstream ... prunt.*

Yes, I saw this—well, something similar—on a coffee mug. It resonated with me. I do hope this timely argument doesn't offend any misguided millennials, cookie-cutter conformists, or our planet's hyperillustrated hordes of inky, illiterate imitators. In that case, *mea culpa*. Or, in our sadly abbreviated lingua franca, "My bad!"

There are so many hipster books with the F word in the title. I've decided to eliminate it from my vocabulary and my work. If it had avoirdupois, I'd use it, but it has become about as power-

ful as the word "amazing." Or for that matter, the word "the."

In my view, it takes real courage to go against the prevailing grain—no matter how gritty, disturbing, and angry the grain. I often wonder at the modern fascination with the morbid, sick, cruel, and violent.

Why we are not *all* crushed to mincemeat every time we cross the street is a sweet mystery to me. With all the threats, both natural and otherwise, to these fragile packets of vulnerable organisms cased in frail epidermides 0.1 millimeters thin, to keep our flimsy lives intact for more than a moment (let alone a lifespan) is a daily miracle to be ecstatically celebrated.

It might be that the most daringly radical, subversive thing one can be these dark days is ... cheerful.

What we do in the workshop is top secret. It's all about surprise, so it must be one.

Surprises are rare in our instantly online era.

Okay, okay. I'll tell you. I get a bunch of people together in a big room, and we

* Nota Bene: For those of you currently serving time at a correctional facility, this particular dig does not apply to you. You are exempt. Nor is it relevant if you are Popeye, Captain Haddock, or my dear dead daddy, a blurry American Eagle perched on Old Glory having somehow landed on his right bicep in 1941. Yes, he was drunk. And there was a war on, okay?

create chaos. And out of that chaos, new and exciting ideas emerge. It's as simple as that.

Ideally, those who take part should know absolutely nothing about what to expect and just show up. I ask former participants (well over five thousand by this time) not to describe what we do and to swear "omertà," the Mafia code of silence. It's kind of fun to be in on a secret pact. Some participants have formed clandestine HTMMOP Facebook groups around the world, just to make interesting friends in new places.

There's also a fantastic resource on Flickr, which is shared here, and includes more than fourteen thousand images, each picture being a page of many drawings. These were made over a period of thirty-five years by thousands of HTMMOP afficionados all over the world. https://www.flickr.com/groups/htmmop/pool/

The zillion things that you'll find there can be your myriad points of departure to make new things, if you so desire. There is no copyright, so feel free to steal them and use them any way you want—a truly astounding resource for all. In my view, another stumbling block to productivity is the yoke of copyright law. As the author of tons of "content," much of which has been stolen, my modus operandi is to be angry briefly, then flattered, then move on and make better stuff for lesser minds to plunder. Plenty more where that came from. I've freely chosen to reap the rewards of a litigation-free life.

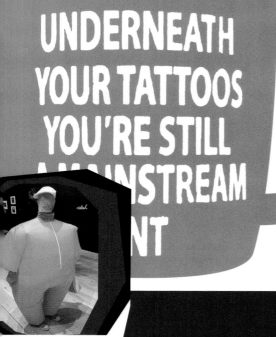

UNDERNEATH YOUR TATTOOS YOU'RE STILL A MAINSTREAM CUNT

And if you can grab a drawing of a pretty flower from that Flickr treasure trove and make a million with it, you're a better man than I, Gunga Din. More power to you.

HTMMOP has all the mystery, glamour, and secrecy of Alcoholics Anonymous, except you don't *have* to be a drunk. There can be no syllabus. It's been held for three hundred people at the AIGA "Next" Conference in Denver and to two very bourgeois Belgian ladies in my New York loft.

"Memphis Soul Stew" (King Curtis, 1967) is our theme song because it sounds like a collage looks.

Apparently, they sell so much of it, people wonder what they put in it. The ingredients are a closely guarded secret but apparently include one pound of fatback drums, half a teacup of bass, and four tablespoons of boiling Memphis guitar.

Our other theme song is "Marcia Baïla" by Les Rita Mitsouko (1984) — just for fun — a fantastic dance track. Why can't we have two theme songs if we bloody well want to? The way I look at it, why else live in a democracy?

In Omaha, Denver, Des Moines, Paris, Philadelphia, Providence, Palo Alto, Prenzlauer Berg, and Pittsburgh, our many participants are full of passion, excited by *doing things*, happy! We sometimes have a dance party after, and there's an excellent playlist on Spotify:

This includes, among 1,172 others:

"Je Suis Snob"
"I Like Bananas Because They Have No Bones"
"Ta-Hu-Wah-Hu-Wai" (Hawaii War Chant)
"Chocolate Salty Balls"
"The Art Teacher"
"Pink Panther"
"Peanuts Theme"
"Prisencolinensinainciusol"
"Schlittenfahrt" ("The Surrey with the Fringe on Top" sung by Marlene Dietrich)
"Að eilífu," or "Aquarius," from the Icelandic version of the musical *Hair*

"How to Make Mistakes on Purpose" has been hosted by all the best art and design schools: RISD, School of Visual Arts, Parsons School of Design, Moore College of Art & Design, Pratt Institute, MICA, University of the Arts, and ArtCenter, as well as Beckmans, HDK and Konstfack in Sweden, Banff Centre for Arts and Creativity in Canada, Camberwell, Kingston, Falmouth University, and Brighton University in the UK, MIMaster in Italy, and Listaháskóli Íslands in Iceland. But HTMMOP is definitely *not* just for designers.

A few of the companies and conferences that have hosted "Mistakes on Purpose" include Adobe, Google, Edenspiekermann, Meredith, Collins, IKEA, Artek, Starbucks, Scholastic, Kikkerland, American Greetings, Johnson & Johnson, The Burns Group, Windquest, 72 and Sunny, SEED, TEDx, PSFK, GEL, Art Directors Club, IDSA, AIGA National Conference, Invisible Conference, Cusp Conference, Grafill (Norway), Art Students League, White Arkitekter, and Society of Illustrators, among many others.

A few years ago, teaching the workshop at the Rhode Island School of Design, I noticed a handsome young man in my class, with long black hair. He said his name was Calle. We chatted a bit in Swedish, a language I speak for no apparent reason. He was quiet, polite, and always the first one in the room. I gave out prizes for best cleaner-upper, and Calle won. The actual prize I gave him was ironic—the infamous Jessica Simpson *A Public Affair* CD. I did the cover lettering—and had twenty sample CDs in my backpack. I inscribed it to him in Swedish:

"*Calle, älskling, jag kommer aldrig att glömma vår passionerade natt tillsammans på Best Western Hotell I Jokkmokk … Puss och Kram! xxxx Jessica.*"

"Darling Calle, I'll never forget our passionate night together at the *Best Western Hotell with two L's* in Jokkmokk … Kisses and Hugs! xxxx Jessica."

The following summer in Stockholm, my friend Tom Hedqvist, then principal of Beckmans College of Design and Sweden's leading design maven, told me he'd heard that the Crown Prince of Sweden had enrolled at RISD.

"There *was* a Swedish guy there … Calle!" I told him. The Swedish nickname for Carl.

But I wasn't sure until I went to the train station and saw all the souvenir shop postcards of the royal family. It *was* him. Calle! This whole time, I didn't know, and nobody at RISD knew, Prince Carl Philip—a.k.a. the Crown Prince of Sweden—walked among them. That makes me a "Kunglig Hovleverantör"—a proud Supplier to the Royal Swedish Crown.

Here is the seal:

Other than Crown Prince Carl Philip Edmund Bertil, Duke of Värmland, who is this thing for?

Animators, Actors, Ambassadors of Buzz, Aspiring Novelists, Announcers, Associate Vice Presidents, Archaeologists, Accountants, Athletes, Architects, Artists, Athletic Trainers, Academics, Beekeepers, Bookkeepers, Bloggers, Bucket Drummers, Budget Analysts, Brand Warriors, Biologists, Copywriters, Coaches, Clergy, Curators, Carpenters, Chefs, Contractors, Chemists, Colon Lovers, Choreographers, Childcare Workers, C-3POs, Culture & Geek Resource Managers, Civil Engineers, Curators, Coders, Chief People Pleasers, Decorators, Directors of Spam Reception, Daddies, Digital Dynamos, Digital Overlords, Drivers, Direct Mail Demi-Gods, Dog Walkers, Drummers, Directors of Storytelling, Deejays, Dancers, Directors, Database Administrators, Designers, Dynamic Social Integrators, Doctors, Digital Overlords, Electricians, Editors, Electromagnetic Wrangler Extraordinaire, Economists, Ethical Hackers, Farmers, Fishermen, Firefighters, Foragers, Fashion Designers, Full Stack Pancakers, FBI Investigators, Financial Analysts, Fundraisers, Flight Attendants, Geologists, Golfers, Go-Getters, Gofers, Gymnasts, Hair Stylists, Head Unicorn Wranglers, High School Students, Human Resources Specialists, Illustrators, Jewelers, Janitors, Knitters, Landscape Architects, Lawyers, Life Models, Librarians, Military Officers, Mechanics, Makeup Artists, Mall Santas, Magicians, Meteorologists, Marketers, Mommies, Marine Biologists, Mathematicians, Musicians, Mixologists, Nurses, Nutritionists, New Media Gurus, Oxford Comma Destroyers, Opera Singers, Oyster Floaters, Oceanographers, Operations Ninjas, Personal Shoppers, Pharmacists, Photographers, Pastry Cooks, People Operations Generalists, Police Officers, Park Rangers, Producers, Personal Assistants, Potters, Psychologists, Public Relations Consultants, Philosophers, Problem Wranglers, Part-Time Czars, Politicians, Poets, Party Planners, Real Estate Agents, Rock Stars, Reporters, Spies, Secretaries, Social Media Trailblazers, Software Ninjaneers, Second Tier Totalists, Salespeople, Space Travel Agents, Software Developers, Social Workers, Statisticians, Tech Monkeys, Typographers, Tweeters, Teachers, Tennis Players, Urban Planners, Volunteers, Videographers, Veterinarians, Wildlife Officers, Waiters, Wedding Planners, Web Developers, Writers, Wizards, Weapons Inspectors, Whiners, Wrestlers, Zumba Dancers, and Zookeepers.

You know, people like that.

You have here an entirely practical way to be creative, productive, innovative. No matter what your job is, making mistakes on purpose will give you a fun and sneaky way to zag while everyone around you can only zig. (Or is it the other way around?)

There are a number of ways of doing this. The following stories illustrate some different ideas, up to and including: bringing in the random, quantity not quality, bringing chaos to your order, misdirection, and more.

Anybody can do it. In Banff, Alberta, Canada, a herd of elk showed up.

Of course we want to make mistakes on purpose. Let's start now!

We ABSOLUTELY GUARANTEE FUN and SURPRISES ●●●●●●●●●●● WE DON'T GUARANTEE ANYTHING

CHAPTER 1
Trying to Be Creative Works About as Well as Trying to Be Charming

As a professional illustrator, I have a perfectly valid fear of the pressure to be creative on demand. It's my job! The thing is, I have a holy terror of the blank page. I can't get started. I'm stuck. Frankly, I'm … focacciad.

Doing *anything* on demand is a problem.

The Performance Anxiety Hiccup Cure

The only way to cure my hiccups is to offer me twenty bucks to hiccup … again. And then I cannot hiccup to save my life. I must get a friend to yell at me, brandishing a crisp Andrew Jackson, if possible.

"Hiccup Now!" Sound of crickets, please. Just one of several reasons I'm glad I'm not a man. Behold the awesome power of my debilitating performance anxiety!

As if that weren't enough, although I'm a regular on the lecture circuit and an experienced public speaker, seasoned educator, and veteran TED haranguer, I also suffer from stage fright, and—more to the point—find it impossible to speak coherently to age-appropriate heterosexual men to whom I have not been formally introduced. *Mistakes* might help with that kind of stuff.*

Starting with a failure helps me get past the doomed feeling that whatever I do is bound to fail. I pick up a random thing. Any old thing! Suddenly, I am not alone anymore with my insecurities, my sad limitations.

I started the workshop because I needed it. Instead of my usual M.O., which is asking, "Who am I trying to fool?" "I'm a total fraud!" "Where do I begin?" "I'm coming up empty!" "What am I going to do?" I get to ask those four magic words: **"What could this be?"**

Setbacks, both global and personal, can lead to great discoveries, astounding adventures, ripping yarns. Certain kinds of challenges

* See "The Opposite" *Seinfeld* episode for impertinent information.

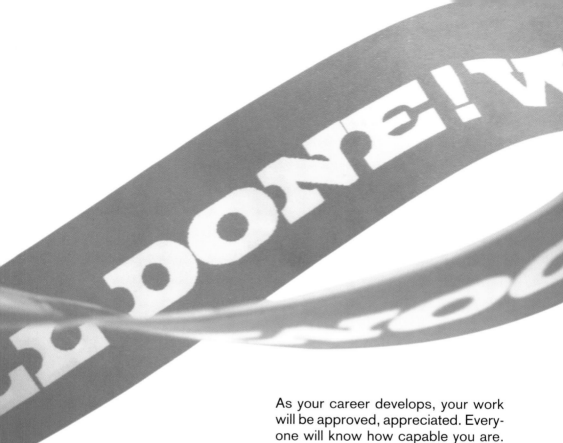

need to be encouraged because our times, difficult as they may be, have been so altered by digital technology that we've lost the urgency, immediacy, and risk that many pursuits used to include.

I'm certainly not the first to believe in happy accidents. The Situationists, Fluxus, Jean Arp, Jackson Pollock, Sigmund Freud, and countless others did, too. Leonardo da Vinci suggested that dirt on a wall or a pattern found in stone could and should be used as a starting point for an artwork.

As your career develops, your work will be approved, appreciated. Everyone will know how capable you are. You become expert at a certain technique or program. You get a good job doing that thing well. You may even become very successful by thirty. Very well, then. But you cannot repeat the same old action and expect some visionary, cutting-edge outcome.

With success, with your excellent results, you develop repetitive work habits and styles that can limit you just as they advance you. Always winning, especially when you start out, can be poison. All that praise may mean you develop a tried-and-true M.O. that keeps you on a Mobius strip that goes no place.

I've learned how to live without knowing. I don't have to be sure I'm succeeding, and as I said before about science, I think my life is fuller because I realize that I don't know what I'm doing.

Richard P. Feynman

1965
NOBEL PRIZE
PHYSICS

Don't you want to generate something meaningful before you die?

Our time is filled with tasks to accomplish, goals to pursue, deadlines to make. In my case, I'm an arm for hire. An illustrator friend once complained to me, "I don't want my obit to read, 'Did a whole bunch of mediocre exercise drawings for *Self* magazine.'" One wants to make some kind of a point, no? There's got to be more to life. And success at thirty means a different thing than success at sixty.

Please, make no mistake. I am a big fan of technology and use it every day, like we all do. I don't want anyone to think I don't love video games and

podcasts and online shopping and iPhones and the Fisher-Price Code 'n Learn Kinderbot and Mac OS Cheetah Puma Jaguar Panther Tiger Leopard Snow Leopard Lion Mountain Lion Mavericks Yosemite El Capitan Sierra High Sierra Mojave Catalina Big Sur or whatever it is now.

But shared technologies, tastes, and similar experiences equal no surprises. Without unforeseen blunders, there'd be no dynamite. No Velcro. And where would we be without Pringles? One shudders to think.

It's not machines I have a problem with. It's the idea of achievable perfection. We need the imperfect. Let us marvel at the important discovery of the inferior glue leading to the Post-it Note, and the less important

(but just as mistakey) pacemaker. Rogaine was originally developed as a blood pressure medicine. Of course, it doesn't cure baldness! But it *was* a famous mistake, and that's my bailiwick.

Not to mention, and in no particular order: Silly Putty, smart dust, Coca-Cola, vulcanized rubber, Crazy Glue, Teflon, the X-ray. The sweet allure of saccharin. Wheaties, unintentional power breakfast of champions. Microwave technology. Behold the glorious Slinky! The triumph of Play-Doh in our time. There's no childhood without Play-Doh.

Whatever you think it is, *How to Make Mistakes on Purpose* … isn't. It is not a creativity workshop. Hell, no! Because you've already got that down.

We all create, constantly, with every bone, every muscle, every cell. Every synapse. It's no big deal! And no, I'm not being literal to be cute. Sometimes when you're just rolling merrily along, suddenly two disparate items can collide in your mind and lead to a great idea.

These natural connections occur to us all, twenty-four seven. One thought leads to another, we don't have to try to do *anything.* And whether these lead to the great American novel, a cure for cancer, or a burst of laughter, it's all creative.

Creativity: The use of imagination or original ideas to create something; inventiveness.
— the Oxford English Dictionary

I rest my case.

Nobody has a brand-new idea simply by trying to. Or by patiently waiting for inspiration. In my experience, it doesn't exist. No divine muse ever alighted on my shoulder, whispering anything whatsoever in my shell-like ear, and I've been brilliantly creative and productive all my life.

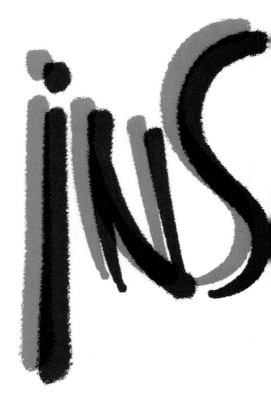

My most hated question? "What inspires you?" And people *always* ask it. Know why? It's the obvious question anyone asks someone in a "creative" job.

Apparently, we mere mortals find it impossible to come up with an original idea. Well, neither can I, bub, unless I trip over the box. The box that I put there on purpose to trip over, but then I forgot I put it there, so I really did trip over it. It has to be real. *I need to fool myself. And I'm no fool.*

WHAT PIRES YOU?

CHAPTER 2
Your Pointless Quest for Perfection

I'M HERE TO HELP!

ME TOO!

YOU ARE NOT ALONE!

YOU NEED ME!

It is absolutely normal to forget that in the twenty-first century we are completely surrounded by the unwavering, reliable results made possible by the machine. We blindly marinate in this ubiquitous cybersauce. The double-edged sword of sophisticated, industrialized know-how means that now three generations of humans have been molded into highly trained, results-oriented workers with demanding, specific roles where they cannot mess up, and therefore they may never be allowed to innovate either.

Behold! Thousands of shiny new apps, sites, products, and services being launched that look and feel and essentially are—the same. Yes, because of technology. Every stroke of the keyboard, every tweet, whoosh, click, and ping, signal an absolute, indubitable certainty.

There's no going back. Nor do we want to. But the way forward can be a lot more interesting and, yes, creative, if you smush together the cyber and the slip-up. If you just blend the bionic with the binary, you don't

have to ditch the digital. There's some book that tells us to Stop Staring at Screens. Won't happen, baby. Get real! I'm not giving up all that. Why should you?

To err is human, but we forget how dependent we are on machines. Computers don't make mistakes. With computers we can deliver infallible results to the powers that be.

Computers help us all be very good at our jobs. I bet you're very good at your job.

But as a human I am not 100 percent perfect.

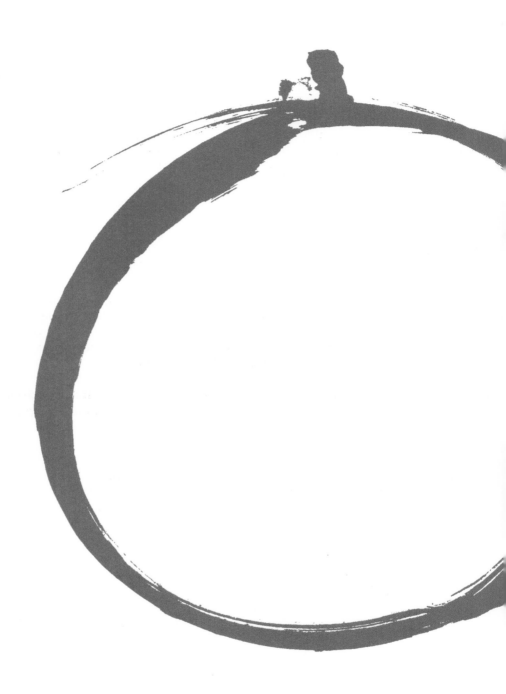

How to Make Mistakes on Purpose

Renaissance painter and architect Giotto quickly drew a perfect circle to prove his creative genius. His confidence was based on thousands of trials. But I can't draw a perfect circle. I have a machine do it for me. I am no genius, so this comes in pretty handy. It is very easy to operate this machine. Conveniently, I forget this incontestable fact. I forget I have spell check, too, and for some reason believe that I am fluent in both French and Italian. *Inoltre, ho studiato Italiano.* For a whole year. Right before moving *à Paris! Mi sbagliavo. Quel idiot prétentieux. Quelle idiote prétentieuse?* The odd-toed ungulates, slubberdegullions, and macrocephalic baboons over at Google Translate neither know nor especially care that I'm a *female* bumblebee pirate clown and that these languages are gendered.

Given identical commands, machines yield identical results, no matter what. Computers can do things we can't. Wonderful things!

Does that mean Adobe Illustrator CC 22.00™ is a better illustrator than Laurie Rosenwald, drawing daily since 1955? I beg to differ. Also, "better"? Really? What does that even mean?

I've trained this brain, these eyes, and these hands for sixty-six years, and my inflated ego refuses to accept the idea that those countless hours have gone to waste. I am not antidigital. Just anti-"exclusively" digital. And resolutely pro booboo.

Digital programs are not only more powerful than a pen or a chisel, they are profoundly, fatally different, in this: a chisel is only as skilled as the person holding it. Also, either one can slip or break. And the differential, the minute nuances involving talent, ineptitude, chance, time, and space, allow all kinds of unpredictable changes to take place. These subtle and uncertain factors at work are where innovations occur.

Computers are unbeatable for achieving consistent outcomes. For planning. Perfection is the default setting, if you're a machine. Because we are comfortable with computers, we are becoming more and more obsessed with planning and organization. All our digital accessories seem to want us to be like them.

Mistakes on Purpose enjoys and embraces the digital—we don't want to ignore it. But we cordially invite the capricious, adorably unreasonable human element into our smart, infallible environment.

To shake things up!

The reasonable man adapts himself to the world; the unreasonable one persists in trying to adapt the world to himself. Therefore, all progress depends on the unreasonable man.
—George Bernard Shaw

I belong to a masterful, ingenious species of weirdos with flaws, quirks, and opposable thumbs! Hooray! I'd gladly tick that box. But are our inconsistencies and idiosyncrasies unique to *Homo sapiens*? No.

From masturbating dolphins to chimps using tools, animals often display behaviors that we'd consider human. So what makes us unique?

Yes, lobsters have serotonin-based reward systems like people—but sadly, they also urinate out of their faces. We are certainly not the only animals that engage in nonreproductive sex. Here, the award for sheer ingenuity goes to the dolphins: there is one reported case of a male masturbating by wrapping an electric eel around his penis.

"What humans uniquely do is that we accumulate culture, and build on it. Many animals learn, but only we teach."*

Most of this book was written on and designed using a Mac. But not all of it!

To keep things popping I need to be able to screw up, and computers can stand in the way. Because that's what all machines are bloody well designed to do!

And that's invaluable, if you expect a particular result. I love my Mac, but I ain't havin' that.

* Excerpted from *The Book of Humans: The Story of How We Became Us* by Adam Rutherford.

The beauty of technology is that it makes all our lives easier and our work closer to perfection.

OR. DOES iT?

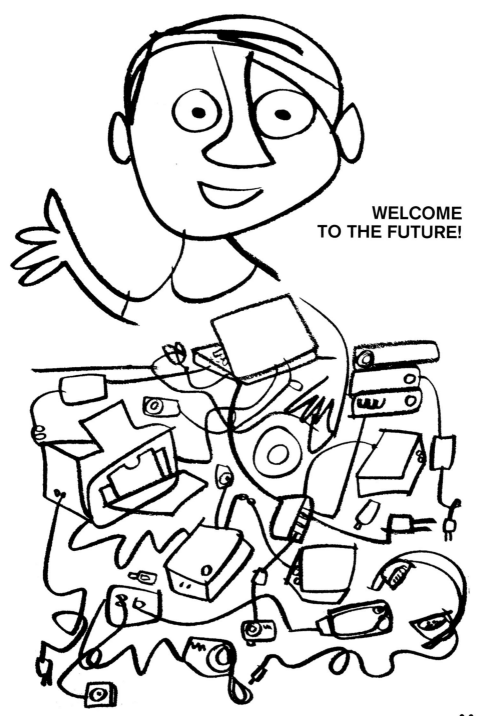

WELCOME
TO THE FUTURE!

CHAPTER 3
FOES: Fear of Empty Space

You never want to be alone with a blank page. You need a starting point.

Avoid the Void: You Need a Burr

One day, back in 1941, Swiss engineer Georges de Mestral went for a walk with his dog in the Jura Mountains. He got some burrs stuck on his pants. Burrs were stuck to his dog's fur, too. He played around with 'em, noticing they attached to each other firmly but could quickly be separated. "What could this be?" thought Georges de Mestral. And now we have Velcro. A great product and a beautiful new word formed from "velvet" and "crochet."

What a sad day!!

Georges de Mestral Is Dead at 82;
Inventor of Velcro in the 1940's

COMMUGNY, Switzerland, Feb. 11 (Reuters) — Georges de Mestral, the 82-year-old Swiss inventor of Velcro, has died, his wife, Helen, said today.

Mr. de Mestral, who spent years perfecting the fastener that revolutionized much of the clothing industry, came on the idea of Velcro after a walk in the woods outside Geneva in 1941. Mr. de Mestral's clothing became entangled in a patch of burrs and, as the story goes, this led him to wonder what made it stick.

Years of research followed, and in 1948 he invented Velcro. Eventually he sold the world license for Velcro and lived on royalties and profits from his Swiss factory, Mrs. de Mestral said.

'Velvet' and 'Crochet'

easily be peeled apart and put together again.

Velcro U.S.A., the American division of the Netherlands-based company Mr. de Mestral helped to establish, estimated that the material could opened and closed up to 50,000 tir without loss of power.

Today, Velcro is used for everyth from keeping astronauts from floatng off the floor of their spacecrafts to keeping artificial hearts in place, as well as the more mundane tasks of fastening clothing.

One of Top 50 Inventions

A group of international inventors voted Velcro one of the century's 50 most important independent inventions. But it was not Mr. de Mestral's work.

Here's what Georges didn't do: he didn't sit down at an empty desk in an impeccable white laboratory and think, "What this world needs is a new way of sticking stuff together, and I'm going to invent an exciting new way of doing that! Stand back! I am now going to be creative!" Oh, no. Something unexpected yet totally ordinary happened that led to … TA DA! … VELCRO!

I wanted to call this book, *What to Do When It's Too Late to Go Walking in the Woods, Get Burrs Stuck on Your Pants, and Invent Velcro All Over Again*, but they wouldn't let me.

Anyway, now you know!

Starting with a mistake … a … "something" saves you from starting out with a nothing, and that makes all the difference. Like Monsieur de Mestral, you need a stand-in for those tiny plant lives that attached themselves to him that lovely day.

Maybe try: But can you plan a happy accident? You can. And you should. Find any random starting point, and start.

CHAPTER 4
Bring Chaos to Your Order

I am deeply committed to creating organized chaos.

Look around you. What's new? Not much.

More than twelve million products are instantly available on Amazon. I don't want to find solutions to problems that just aren't important anyway. We don't need yet another meaningless widget.

In one popular category, Electronic Accessories, best-sellers include portable speakers, cables, and screen guards. Excited? Me, neither. Also, inflatable lounges, for some reason, are selling through the roof. But no cure for cancer, AIDS, or the common cold.

I've often thought it would be great to cause a computer virus (!), which does exactly that—injects a random

word or image and has it flash on computer screens—but maybe only three or four times a year at unpredictable times, just to goose things up. Brilliant idea, or barmy? What do *you* think?

"BREADFRUIT!"

"PUMICE"

"SMOCKING!"

The Big Idea is to make stuff first, figure it out later. If you spend most days problem solving, maybe try doing that just once—just to see what happens. Stephen Hawking, R. Buckminster Fuller, and Johnny Cash have all been widely quoted as grateful mistake-makers, not to mention Tina Fey. Listen to The Man in Black.

CHAPTER 5
Divine Accidents

The *combination* of our twenty-first century's safe, clean, digital environment *with* the chaotic, messy, unpredictable, and sometimes dangerous human element is precisely what allows for what filmmaker Orson Welles called "divine accidents." If you insist on working with digital media *alone*, two things are guaranteed:

1. Good, reliable results.

2. You will find it difficult, if not impossible to experience a divine accident and the excitement, the genius that Welles describes. In an interview with Welles, which is available on YouTube, he expressed this special aspect of filmmaking:

Orson: *Everything else I've ever done has been controlled. Every frame is controlled. But I would like to take a whole story and make the picture as though it were a documentary, but the actors are going to be improvising.*

Reporter: *That seems to me like shooting and shooting ... and aren't*

you afraid the end result won't have any control?

Orson: *Not a bit. No I really am not. The greatest things in movies are divine accidents. ... My definition of a film director is the man who presides over the accidents. There are these divine accidents. It's the only thing that keeps films from being dead. Every time one would happen, BOOM! Genius would come out. Everywhere there are beautiful accidents. There's a smell in the air—there's a look ... that changes the whole resonance of what you expected. Sometimes I've had those accidents. I made a picture in which somebody reached through a window, in* Touch of Evil, *and found the egg, and we made a whole scene about it. But I want to go further.*

Reporter: *It sounds as though the whole thing is going to be a whole series of your divine accidents—*

Orson: *If we're lucky. ... We're going to go fishing for accidents, which I think can be very exciting!*

Something That Happened

A similar brainwave occurs to Herbie Hancock as he talks about playing piano with jazz trumpeter Miles Davis: "When right in the middle of Miles's solo in the aptly named 'So What,' I played the wrong chord. Miles paused for a second, and then he played some notes that made my chord right, it made it correct. Which astounded me—I couldn't believe what I heard. Miles was able to make something that was wrong into something that was right. ... I couldn't play for about a minute—I couldn't even touch the piano. ... What I realize now is that Miles didn't hear it as a mistake. He heard it as something that happened—just an event—and so, that was part of the reality of what was happening at the moment and he dealt with it. ... That taught me a very big lesson about not only music, but about life."

Miles Davis knew it, Orson Welles knew it, and Stéphanie Tatin is about to find out.

La Tarte Tatin!

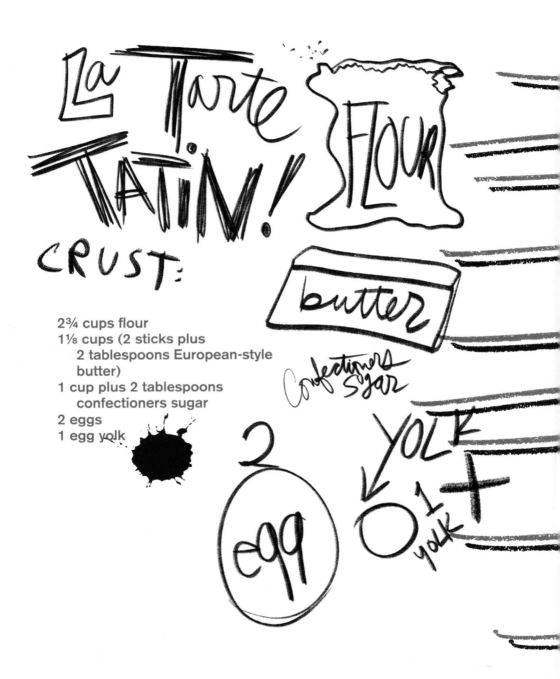

CRUST:

2¾ cups flour
1⅛ cups (2 sticks plus
 2 tablespoons European-style
 butter)
1 cup plus 2 tablespoons
 confectioners sugar
2 eggs
1 egg yolk

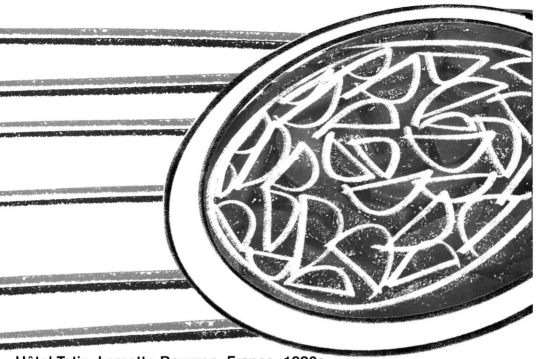

Hôtel Tatin, Lamotte-Beuvron, France, 1880s

Stéphanie Tatin started to make an apple pie but got distracted and left the apples cooking in butter and sugar for too long. You know how that goes. Typical! The whole thing was burnt (but must have

smelled marvelous), so she tried to save the disaster by putting the pastry crust right on top of the burning apples and served the whole thing upside down.

Quel culot! An *étoile* was born, becoming one of France's most illustrious (and delicious) desserts, adored worldwide to this day. **La Voilà!**

1 cup sugar
4 tablespoons European-style
 butter
¼ cup water
5 Golden Delicious apples,
 peeled, cored, and
 quartered

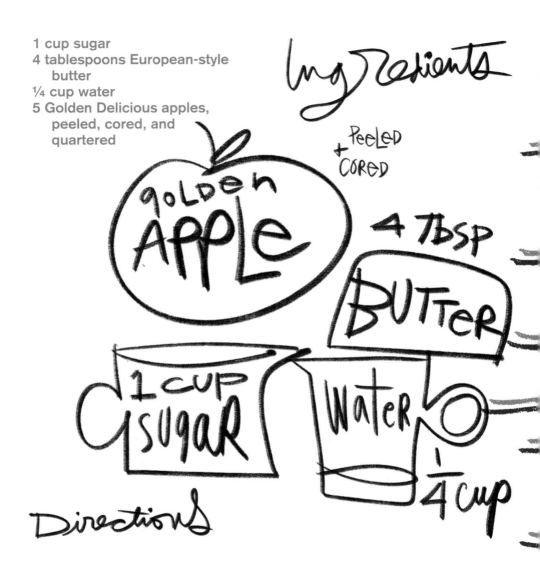

1. First prepare the crust. With an electric stand mixer or hand-held mixer, combine flour, butter, and sugar until the mixture has the consistency of small peas. 2. With the machine on low speed, add eggs and yolk, and mix just until well-incorporated, about **25** seconds. 3. Wrap the dough tightly in plastic wrap and chill for at least **30** minutes before rolling out.

1. Preheat oven to **400**°F. **2.** For the filling, place sugar, butter, and water in a **9**- or **10**-inch cast-iron skillet over

medium-high heat. **3.** Cook until mixture becomes golden

brown and bubbly. **4.** Remove from heat and allow mixture

to cool to room temperature in the dish. **5.** When caramel has cooled, arrange the apple quarters on their sides in the

mixture. **6.** Roll the pastry dough out to a thickness of about ½ inch and a diameter large enough to cover the dish. **7.** Place dough on top of the apple mixture then trim and dis-

card the edges. **8.** Bake **40** minutes. **9.** Allow to cool in the

dish for **15** minutes before **inverting** onto a serving platter.

Je Suis Bouleversé! Translation: I'm stunned! I am shocked! I am flabbergasted!

Bouleversé literally means turned upside-down.

NOTE! It turns out that the story that claims that the renowned tarte was discovered by accident is pure *merde de cheval*. The Tatin sisters were skilled restaurateurs and marketing experts who knew exactly what they were up to.

The Streetcar

Guillaume Apollinaire was quoted as saying that he wanted to be run over by a streetcar *so that something would finally, finally happen to him*. And this from someone whose circle included Picasso, Gertrude Stein, and Cocteau, who coined the term "surrealism," and whose erotic novel is titled *The Eleven Thousand Rods*.

Guillaume wanted … more. Me, too. And the more I want is *fun*.

The First Pancake

As a lonely child, I learned that your own company is the only thing you can count on. So if you can be happy creating stuff on your own, you can have fun every day of your life. I wrote this thing to help people get started. By Making Mistakes on Purpose!

The Eleven Thousand Rods

G.A.

CHAPTER 6
Fireworks, Viagra, LSD, Champagne, Pringles, and Popsicles? Yes, Please

Eureka (Greek: Εύρηκα) is an interjection used to celebrate a discovery or invention. It is a transliteration of an exclamation attributed to ancient Greek mathematician and inventor Archimedes, who after he got into a bathtub, noticed that the water level rose and realized the volume of water displaced must be the same volume as the part of his body under water.

"Εύρηκα!" shouted Archimedes. I wonder if he was fat and if there was a big splash.

Now volumes, masses of any shape could be measured precisely.

Alexander Fleming, a bacteriologist, was never alone in a clean, white lab. He had his icky mold to keep him company. This filthy little anecdote might serve as an excellent excuse, should you need to defend your, um, controversial approach to housekeeping.

Penicillin was discovered in London in September of 1928. Fleming returned from a summer vacation to find he'd left a filthy dirty lab bench—a big mess. He noticed that a mold called *Penicillium notatum* had contaminated his abandoned Petri dishes. Under his microscope, he saw that the mold prevented the growth of staphylococci. He realized this Penicillium mold might be harnessed to combat infectious diseases.

Fleming wrote, "When I woke up that morning, I certainly didn't plan to revolutionize all medicine by discovering the world's first antibiotic, or bacteria killer. But I guess that was exactly what I did."

Fleming and I have much in common. He was also a member of the Chelsea Arts Club in London. He also considered himself an artist and created truly mediocre watercolors, but that is where the similarity ends.

What is less well known is that he also painted ballerinas, houses, soldiers, and mothers feeding children *in bacteria.*

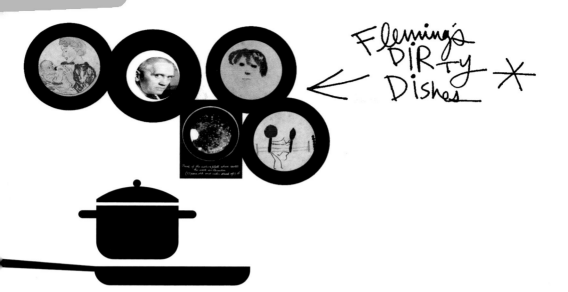

He would fill a Petri dish with agar and then use a wire lab tool to "color in" sections with different species. He had to time his inoculations so different species all matured simultaneously. One of them looks like chicken drumsticks in a boxing ring, and *all of them are disgusting*.

Stedman's Medical Dictionary defines "serendipity" as "finding one thing while looking for something else."

The origin of "serendipity" actually derives from "The Three Princes of Serendip," an ancient story from Persia. These princes discovered much that "they were not in quest of," including, among other things, a missing camel.

Horace Walpole read a later version, coining the English term "serendipity." This same tale inspired Voltaire to write *Zadig*, which inspired Edgar Allan Poe in his thriller, "The Murders in the Rue Morgue," which in turn inspired Conan Doyle to write *A Study in Scarlet*, the very first in the sublime canon of Sherlock Holmes adventures. The detective as obsessive compulsive hyperobservant master of deduction is born, initiating a fantastic genre of literature.

It just struck me that many of the well-known items invented by accident are particularly fun and exciting. Fireworks, Viagra, LSD, Champagne, Pringles, and popsicles?

Yes, please. It's party time!*

* And if things go south, the morning after … there's always **penicillin.**

Mistakes on Purpose is about discovering sweet, fizzy, sparkly, and refreshing things. And bouncy things! I know from experience that making mistakes in the spirit of curiosity is an excellent way to live one's life, and in no way guarantees ... anything. Except fun. *Very* occasionally these things turn into fame and big money, but that's a whole nother story.

It was the late nineteenth century. Thomas Adams was frustrated. His rubber replacement made out of Latex was just not working. *So he put a piece in his mouth*. You know, like you do ... he found this gunk weirdly enjoyable to chew on. He added some flavoring and called it "chewing **gum**." It stuck.

During World War II, Richard James was working on a gizmo to measure the horsepower output of ships. One of the springs fell off a table and just started to walk away.

It makes a superb tunnel for pet mice and, of course, an object to demonstrate transverse and longitudinal waves. If you have a bag of peanuts and a coat hanger (and we know you do), you can make a birdfeeder out of it. But its best known as a stair walking toy.

Everyone knows it's **Slinky**.

John Pemberton was a pharmacist who just wanted to cure headaches. He thought a combo of coca leaves and cola nuts might just do the trick. His lab assistant* accidentally mixed these together with carbonated water, inventing the first **Coca-Cola**. Pemberton died before seeing the huge success of his invention.

As of July 9, 2019, Coca-Cola's market capitalization was just under $224 billion. *Market capitalization? Why do people have to talk that way?* Anyway, sounds like an impressive wad of dead presidents.

Oh yes, I remember it well! The year? 1490. The place? La région de Champagne à France. You wore green glass, I wore gold foil. Then, we were both wearing nothing at all. The weather turned suddenly glacial. The chilly temperatures made the yeast stop working too early, and carbon dioxide formed in the wine, which fermented in weird and wackadoodle ways. We survived by imbibing the exploding bubbles and huddled tightly together for warmth. We have climate change to thank for **Champagne**.

In 1839, Charles Goodyear was experimenting with natural rubber and accidentally dropped some on a hot stove, making it instantly weatherproof. Like many others, Charles died $200,000 in debt. And, yes, the Goodyear **Tire** and Rubber Company was named after him forty years later.

It's one thing to make good mistakes, but to capitalize on them takes good luck. And timing. For that, *may the hamster gods be with you!*

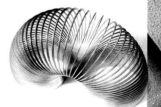

* *Also, why wasn't the lab assistant named?*

How to Make Mistakes on Purpose

In 1945, Percy Spencer, while employed by the Raytheon Corporation (I know this sounds made-up), was experimenting with a magnetron vacuum tube, the way one does, when a candy bar in his pocket suddenly melted. Instead of being simply sticky and annoyed, he tried melting popcorn, with explosive results. Thus was born the mighty Radarange, a **microwave** five and a half feet tall, weighing 750 pounds, and costing about $5,000.

While trying to create synthetic rubber during World War II, James Wright dropped boric acid into silicone oil. The result was a substance that bounces, picks up dirt, lint, and hair, stabilizes wobbly furniture, and secured tools in space for the Apollo 8 astronauts. **Silly Putty** also has practical uses.

In 1970, Spencer Silver, a researcher for 3M, had been trying to create a strong adhesive and instead developed an extremely weak, inadequate one. In spite of this, he decided to give a fascinating presentation about his pathetic, ineffectual glue. Arthur Fry, an engineer at 3M, had been present at this historic moment. Spencer did attempt to interest the people at 3M, but they were unanimous in their apathy.

Anyway, this Arthur character sang in the church choir. He liked to put little pieces of paper in his hymnal to mark the correct songs. A mere four years later, he thought, "What's the point of a glue that doesn't stick well? I've got it! A removable bookmark!" ... which became one of the most widely used office products in the world: the **Post-it Note**. 3M made $32.8 billion in total sales in 2018. "In weakness lies strength," sayeth the Lord?

Dateline: 1880

Place: Johns Hopkins University, Professor Ira Remsen's Laboratory

Constantine Fahlberg spilled a chemical on his hands and forgot to wash them before lunch (tsk, tsk!), which tasted unusually sweet. In 1884, he got a patent on this careless mistake, but saccharin did not become successful until sugar was rationed during World War I. In 1957 the pink packets made their **Sweet'N Low** appearance.

Astronomers Robert Wilson and Arno Penzias heard some funny noises, like radio or TV static, while they were working with the Holmdel antenna somewhere in Jersey. They thought there might be pigeons living in the antenna.

The team was keenly aware of Robert Dicke's universe-forming theory and realized their "pigeons" were evidence of cosmic radiation left over from the formation of the universe. The **Big Bang theory**. BANG!

Frank Epperson was trying to make homemade soda. After all, he was an eleven-year-old boy. He left his mixture outdoors with a stirring stick in it. The temperature dropped, and when he woke up the next morning he found … ta da … a **popsicle**.

Railroad magnate Cornelius Vanderbilt was worth $105 million at the time of his death in 1877. And because he could afford to be, he was a very, very picky eater. At a restaurant in Saratoga, New York, he kept sending his fried potatoes back to the kitchen, complaining that they were too thick and soggy. Every time they were sent back, chef George Crum cut them thinner and thinner, finally frying ultra-fine slices. Then Vanderbilt said they were too thin to be picked up with a fork. But soon, everybody in the place wanted some Saratoga **Chips**, too.

Yes, I use Wikipedia and then change the words around. That's what it's for, right? Unfortunately, my research into "wealthiest" (a tangent leading from Vanderbilt) brought me to this:

List of wealthiest animals: Olivia Benson (Taylor Swift's cat) has an estimated worth of at least $97 million. Sorry I mentioned it. Although I do have real admiration for any animal bearing a respectable surname.

GOLFING
FOR CATS

ALAN
COREN

CHAPTER 7
The Problem with Problem Solving

When you write or create in order to expressly realize the prevailing data, you are nothing but a hack. Also, your business will probably thrive. But this is not a book called *How to Make Tax-Free Billions and Retire Early*! It is a book for people who want to spend their precious time on this planet doing something enjoyable and meaningful to them, that makes them … as happy as can be expected (considering that the world is now and has always been a vale of salty tears).

In 1976, the year British humorist Alan Coren published this brilliantly funny book, it seems that most best-selling books were all about cats, golf, and the Third Reich. Hence this book cover and title. Makes perfect sense to me! This is the logical solution. You might even say the ultimate one.

I cannot and will not cut my con-science to fit this year's fashions …
—Lillian Hellman

Big Pharma's Big Phailure

Interviewed by Malcolm Gladwell, author of *Blink*, at the New Yorker Festival, Dr. Safi Bahcall of Synta Pharmaceuticals says that in a single year, the six largest pharmaceutical companies spent a total of $20 billion on research and development. The number of FDA-approved drugs resulting from all this?

Zero.

In his opinion, this is the outcome of Big Pharma's habit of stifling real innovation by not allowing for mistakes to happen. These huge companies are so well organized, there is no place for the serendipity that led to penicillin, the X-ray, pacemaker, and many other marvels at a time before digital perfection, when the unintentional was possible, perhaps even prevalent.

According to my Google search, which I don't trust anyway, fifteen new drugs were produced that year—but never mind. I think what Bahcall meant is there wasn't a discovery as major as penicillin. No cure for AIDS or cancer. We'd all know if they'd got those sorted by now, right?

Now, in most jobs, everyone has a specifically defined role. People are looking for certain results. I guess they find them. What a snore!

I'm not suggesting we unlearn how to play the piano, speak French, tie a slip knot, kickbox, make spaghetti, or drive a car.

I am not denouncing expertise, education, problem solving, or research. I am not promoting idiocy. There's a large, economy-size basket of deplorable, antiscience morons around—in America, we've got that well covered, thank you.

I prefer a little hocus pocus.

Of course, new ideas may not often succeed. But ... so what? Every experiment, every failure is another red circle under your belt, and each one counts.

I feel strongly that education forces us too much on careers, anyway. *Focus.* I do not like that word. I say, mix it up.

And not so incidentally, all the best musicians went to art school: David Bowie, the Beatles, the Talking Heads, Ronnie Wood, Syd Barrett, Keith Richards, Mick Jones, Michael Stipe, Joni Mitchell, Tupac, Nicki Minaj, Freddie Mercury, Karen O, Florence Welch, Kanye West, M.I.A., Pete Townsend, Jimmy Page, Eric Clapton, Lady Gaga, and Tony Bennett.

Before penning Girls L.G.B.N.A.F., Ice-T studied architectural drafting.

Among my accomplished friends, it turns out that comparative literature students make great chefs, and the best novelists dropped out of law school. My education taught me to seek out the passionate, interesting teachers I admired, no matter what subject they taught. It's always all about personality.

Just as the wrong point of departure can create an epiphany, *the "wrong" course of study can challenge the brain and enlarge your future.*

As a substitute teacher at a public school in Queens, one of the saddest things I can recall is the enthusiasm and pure joy a class of seven-year-olds experienced when we painted and made collages together. Those kids were jumping out of their skins, hugging me! I found out that even at that age, the school never, ever let them create things *just for fun—* everything had to be tied to a particular lesson plan and yield measurable results that could be tested. The only school texts they read were precisely fitted to their limited vocabulary, their exact age, to a minute degree.

But I thought school was a place to experiment!

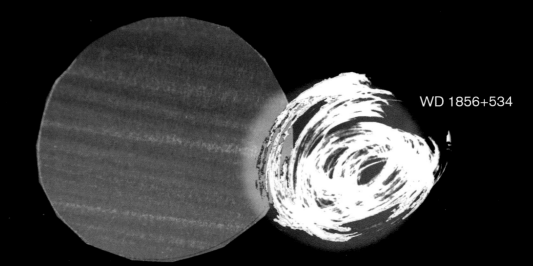

WD 1856+534

You have plenty of time to feel trapped and stifled at forty-one, but at twenty-one (let alone seven) it's a crime.

If the things you enjoy doing seem strange to others, keep in mind that these *actual courses of study* would have been considered insane, unimaginable science fiction when I was at college:

Game Theory with Engineering Applications
AI for Impact: Solving Societal-Scale Problems
New Culture of Gender: Queer France
The #selfie
The Politics of Kanye West: Black Genius and Sonic Aesthetics
Intersectional Feminist Memoir
Computational Biology: Genomes, Networks, Evolution
Lemonade: Black Women, Beyoncé & Popular Culture
Surviving the Coming Zombie Apocalypse: Disasters, Catastrophes, and Human Behavior
Patternmaking for Dog Garments
and
Wasting Time on the Internet
 … let alone **Web design**, which now sounds a bit like **"Butter Churning."**

Maybe you're ahead of your time! Tell everyone you're a visitor from the white dwarf WD 1856+534. That should shut them up.

What is the point in being so vocation-oriented, when the vocations haven't yet been invented?

Maybe try: When you have an important life decision to make, toss a coin and then see how you feel. When you think you must obey the chance "decisions" of the eight ball or the pin in the map, and you are disappointed or glad with the outcome, it helps you know what you really wanted. So do that, whatever the stupid eight ball says. Go with your feeling. Nothing but feelings are real.

CHAPTER 8
Sometimes Not Trying Works Better Than Trying

In one scientific study, college students were asked to solve a brain teaser early in the morning and late at night to measure problem-solving abilities relative to alertness levels. Prior to answering the riddle, most students self-identified as night owls, implying they would be better equipped to answer the question in the evening when they were more alert. The researchers were surprised that more students solved a riddle when they were still half asleep or drunk, than well-prepared, alert, and sober.

I know from experience that a disciplined, focused brain intent on study and concentration can weed out many random, seemingly extraneous or disparate, unconnected, illogical thoughts that often lead to the most imaginative solutions. In other words:

"Trask, Radio! Trask, Radio!"

What am I talking about? I often show a clip from the 1988 film *Working Girl* to illustrate a point: not trying often works better than trying. What creates breakthroughs are the unconscious, natural, easy connections we all make in our minds all the time.

In *Working Girl* (directed by Mike Nichols, screenplay by Kevin Wade), Melanie Griffith plays Tess, a low-level secretary at a big investment firm. She's working-class from Staten Island. Her hair is big, bleached, and very, very fluffy. The shoulder pads alone are worth the price of admission.

While her arrogant boss, Katherine (played by Sigourney Weaver), is away on a skiing trip, Tess sees an article on corporate giant Trask in *Forbes*, and then two completely unrelated items in the gossip column of the *New York Post*.

The result is that Tess has a brilliant idea for a corporate merger around which the plot revolves. Reading gossip columns is fun. It's easy and lazy! Here we see a perfect example of the way human brains work best, in fact work harder, if we allow them to play. In the "background," Tess's playful, diverted brain takes in two unrelated things. She puts the two together.

Typically, because she's just a flunky — and "dumb blonde," an outer-borough bimbo — nobody believes the idea was Tess's own, once all-powerful Katherine returns and has stolen the credit from her.

That vicious, power-suited virago fires Tess, who, while exiting the office in blue jeans and disgrace, runs into CEO and uberboss Trask in the elevator.

She gets a chance to explain how she came up with the big idea, telling him how she'd seen a piece in *Forbes* about Trask's plans to expand, and on page six of the *Post*, an item about a radio talk show guy. Then she'd noticed, in the gossip column "Suzy,"

a photo of Trask's daughter, who was organizing a charity ball.

"So I started to think, 'Trask, radio … Trask, radio.'"

Katherine storms into the office, shoulder pads ablaze. Trask challenges her, asking how she first thought up the same idea.

Katherine says, um, she'd, um, have to check her files.

Clearly, *she's* the liar. Trask makes a helpful suggestion:

"Get your bony ass out of my sight."

The point is, *Tess wasn't trying.* She didn't sit down and try to invent a great business idea. *She was doing what she enjoyed* and had the light-bulb-on-head epiphany we all long for.

After all, her infamous line in the movie is …

You Know the Way You Are? Well … Be That Way, only More So!

Maybe try: GIVE IN. Crank it up to eleven. Unless it harms yourself or others, whatever you enjoy, take it even further. And if that means gossip columns, a 4 a.m. stroll, Extreme Ironing, or the Krispy Kreme diet, who cares? Take an eight-hour bath. Wear a monocle. Take up Element Collecting, Geocaching, or Competitive Duck Herding, if your interest is genuine.

Armageddon will not break loose should you choose to eat salt and vinegar potato chips for breakfast or sleep on the fire escape. Go your own way. It may lead to glory. Or not. Nobody knows, but that's the whole point—not knowing. "Just because I like it!" is not only an acceptable reason, it's sometimes the best.

CHAPTER 9
Mindfulness Causes Angst, or Why P. G. Wodehouse Is My Therapist

I go to great lengths to avoid my own thoughts. Why? Because I think there may be some squirrels in there.

I can recite *Love Among the Chickens* nearly verbatim. I've listened to every single episode of *Seinfeld*, *30 Rock*, *Toast of London*, and *W1A* "in the background" about a hundred times, and this has helped me *not* concentrate on what I'm doing, which makes things easier, somehow. This is one of the many ways I fool my addled brain into not worrying about whatever tomfoolery I'm worried about at the moment.

This may be the exact opposite of what those bleating Internet sheep refer to as "mindfulness." I have no idea what mindfulness is, but for me, *Leave It to Psmith** read by Hugh Laurie on YouTube helps, and transcendental meditation does not.

Suddenly, it occurs to me that the dialogue taken from this particular scene in *Trouble in Paradise* (1932) fits in nicely with our "Mistakes" theme, if

Anders Wenngren

only because *I happened to be listening to it while writing the previous paragraph*, to distract myself from writing. My brain is happier when multitasking.

The screenplay is by Grover Jones and Samson Raphaelson. It is considered to be producer/director Ernst Lubitsch's greatest film.

Note: Because Jerry Seinfeld swears by it, *and for that reason alone*, I have tried to meditate but just ended up thinking about my mediocre dishwasher and wondering if I've inherited a bicuspid aortic valve situation, not to mention my humiliation, flunking

* The "P," of course, is silent.

a nonexistent but vitally important course: Meditation 1.

And ... say what you want about crack, it sure does get you high! Just kidding. Hard drugs are always bad news. You don't want an addicted body. You want a refreshed, relaxed brain. For "Working Girl" Tess, it meant reading a gossip column or two.

Personally, I have more brainstorms when I get up at 4 a.m. than 4 p.m. at my desk.

Keep a recording device or notepad near you always. Because the best ideas sometimes arrive when you are semiconscious or "otherwise engaged."*

What helps *you*? I had a boyfriend** who chewed on big wads of paper while he wrote. I think this is revolting (as well as ironic), but it doesn't matter what I think. It helped him, an NEA Fellow, PEN Revson Award winner, Guggenheim Fellow, and finalist for the National Book Critics' Circle Award.

This may not seem like good advice. But if it helps you, who cares?

* Yes, that's just like "the shower principle," and yes, I'm aware they beat me to it.
** Did you know that people write their own Wikipedia pages? Well, they do.

Maybe try: Watch television or listen to loud music or podcasts while you create, if that distracts you from your precious, all-consuming obsession. Vacuum the house with your iPhone on Voice Notes while you scream and shout your Great American Novel into it.
Whatever works. Use technology for what technology's so good at. I like free audiobooks on **Libby** and vintage eyeglass frames on **eBay**. And sure, I like being entertained by entertainment. **Netflix?** Nightly! **Hulu? And how!**

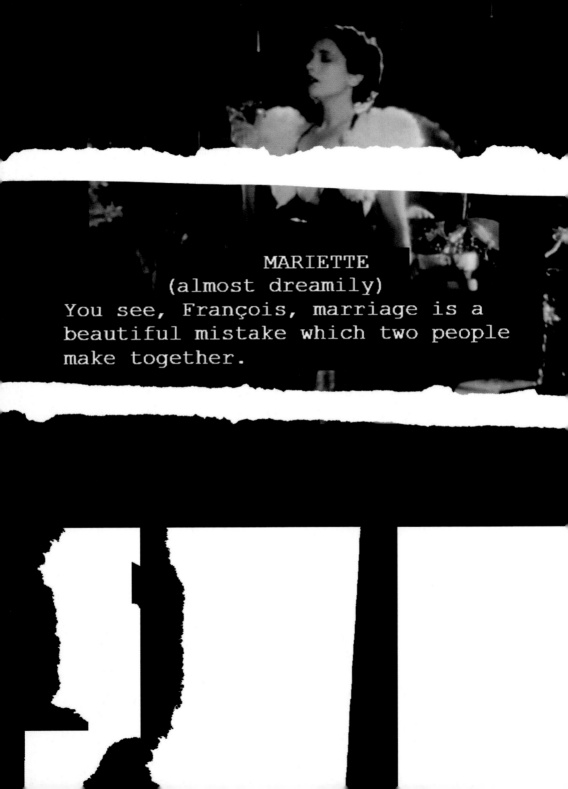

MARIETTE
(almost dreamily)
You see, François, marriage is a
beautiful mistake which two people
make together.

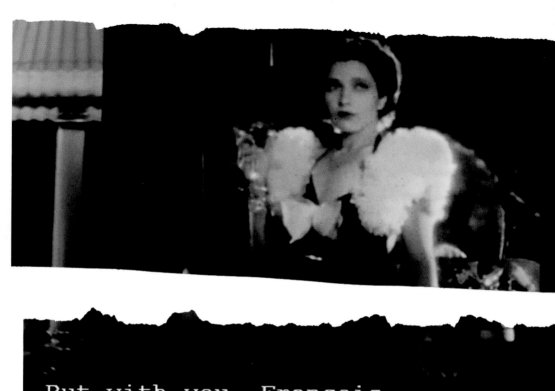

But with you, François--
 (Friendly; shaking
 her head.)
I really think it <u>would</u> be a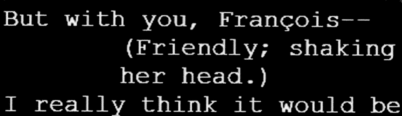
mistake.

CHAPTER 10
Errare Humanum Est!

 TikTok TikTok

Time is passing. Face it, we're all **Terminal**.

One third of our **iLife** is spent at **iWork**.

That's 90,000 hours over the course of a lifetime.

But I just can't seem to **Procreate** anything new.

I can't **Access** my **CreativeCloud**.

There must be a better **waze**

 yelp Me!

I'm so much more than a **TaskRabbit**

I'm a **realplayer**

I am not a robot!

Oh, really? If I have to click that bloody reCAPTCHA one more time ...

well, maybe I *am* one. How many times have you had to prove you're *not* bionic by clicking on images containing traffic lights?

How many hours angrily unsubscribing yourself, answering robocalls?

Pressing one, two, or three?

I would like to register a livid, vociferous complaint on the part of humanity please, which will fall upon deaf ears, as bots do not have any.

Have we *all* become automatons?

Hell, no!

I'm a writer, painter, illustrator, animator, graphic designer, product designer, portrait artist, typographer, and teacher.

(And, unfortunately for you, a former standup.)

Being human, I am lazy.

It's so easy to repeat tried-and-true habits
and get calculable results ... *Instagram*

Because computers don't make mistakes, I can promise my clients ...

"Problem solved!" It's seamless

Adobe? Absolutely.

InDesign? Indubitably!

And yet ... I don't **Excel**.

But before I shuffle off this mortal coil ... before I **StuffIt** ,
I want—no ... I *need* to create an idea that is beautiful or useful and
brand spanking new.

I want to make a lasting, meaningful **PowerPoint**.

And new ideas don't fall from the clear blue Skype

I've discovered that in order to create something interesting

I need to blend the foolproof with the faulty.

The rational with the wrong number.

The precise with the personal.

I can't depend exclusively on that machine.

Because I am a person.

A mere mortal.

CHAPTER 11
Do the Random Thing

Pure Gold!

Kurt Andersen, the host of the Peabody Award–winning public radio show *Studio 360* and author of *Evil Geniuses*, said, "Playing with the *Studio 360* staff for an afternoon under Laurie Rosenwald's Yoda-ish supervision was like eating a certain candy bar, indescribably delicious. And unlike eating a candy bar, it was also sublimely useful."

Vicious Yoda comment aside, I will always be grateful to Andersen. He took part in a "Mistakes on Purpose" workshop the year he emceed at the American Institute of Graphic Arts annual conference in Denver, Colorado. Kurt really understood that it's about a way of life—approaching any problem whatsoever and not particularly design-oriented ones.

gold

He then invited me to host the workshop for his team at *Studio 360*. Think about it. Radio. Not the most visual of mediums.

A few days before the workshop was to take place, his producer phoned to ask me how my "Mistakes" theory would help nonvisual problem-solvers. Your average citizen. Valid question! I said, "Imagine you're a radio producer." And he said, "I'm listening!"

"For instance, you could ask me, 'Laurie, how long have you been doing this?' or 'Where did you get the idea for the workshop?' or 'Where did you grow up, or go to college?'" I said. None of these are bad questions—they are all valid, if somewhat common ones. No-brainers. That's standard problem solving at work. Nothing wrong with that ... but what if you want a ... YES BRAINER? Something fresh and crunchy?

OKAY! Maybe you could select an object that happens to be on your desk and let *that* be the question, or suggest one.

Still on the phone, to demonstrate, I turned the tables and tried it myself. Two inches from my left hand was the novel I happened to be reading. I opened to a random page and let the first two words on the top paragraph determine my line of inquiry. They were these: "GOLD BULLION." Bars of gold. Bling. Chedda. Scrilla. Chips. Deniro.

That random phrase might lead you to this question: "Laurie, is this some art school, underground thing? Or are you hosting this workshop for huge corporate off-sites and *raking in the big bucks*?"

Maybe it's not the best question *but probably one you might not otherwise have asked. And that has enormous value.* In fact, IT IS PURE GOLD.

So, let the random, *in tandem* with everyday problem solving, help you toward something new and different. And no, I'm not asking you brain surgeons to spontaneously switch out your scalpel for a stalk of asparagus. It's active, conscious sabotage. Not business as usual. *This* is the monkey wrench in the gears. There's liberty, infinite possibility in the arbitrary, when used with discretion. If you crumple a piece of paper and announce "BEHOLD! Here is the new Bridge to Ireland!" ... beautiful, revolutionary, except cars can't drive over it ... you need to palliate your courageous crumple with problem solving.

Maybe try: The very next time you need to solve a problem and you're stalled ... go for the first thing you grab, not the best thing. Not the right question or software or product or paragraph. The easiest, closest thing. Problem solving **alone** can only go in one direction: toward your known goal, step by step. But **including** a random element will give you an edge because you will be led astray, toward the unknown, the untried, the un-done. **Try it.**

LOTS of GOOD Things are MISTAKES

i was a mistake.

Reading a book on evolution and ex-
tinction, we learn that we, humans,
are essentially the result of some
kind of genetic mistake (in the way
of a mutation). We are all mistakes!
—John Gall

Take that, White Supremacists.

Yes, we human beans are the mish-mash result of whatever the opposite of family planning is. And it's a good thing, too. Several studies have shown that mixed-breed dogs have a health advantage. A German study (and the Germans should know) found that mixed-breed dogs need less veterinary care, are prone to fewer diseases, and live longer. Swedish researchers stated that mongrels are consistently at lower risk for disease than most purebred dogs, and data from Denmark also suggested that mixed breeds live longer compared to pure breeds. As long as we don't drink out of the toilet and keep boning whoever we want, indiscriminately, our species should continue as long as it takes to destroy our home planet entirely!

Maybe try: So don't be so picky. Woof!

CHAPTER 12
To Zig When Others Zag

At the Rhode Island School of Design, the Illustration and Graphic Design departments were in separate buildings—they weren't even sleeping together! Shocking.

I never thought Illustration should exist as a major in higher education.

I went into Graphic Design because I love typography. In the '70s, what I called the Swiss Miss style prevailed. Serious theories via Basel. Words like "vernacular" and "semiotics." "Univers" was the only acceptable typeface and grid systems galore. No pictures allowed, unless they were particularly boring, grainy, black-and-white photos of concrete walls or abandoned gas stations. Those grey squares bored me to tears. And I missed drawing, humans, humor, and color, so …

I transferred to the Illustration Department. Every single piece I produced included typography, and the teachers didn't think that was illustration, really. I was not encouraged to "mix" these sacrosanct disciplines.

They wouldn't let me back in the Graphic Design Department, unless I enrolled for a whole extra year. Clearly, graphic design is a very Serious Thing. The Big Choice of Major had become such a source of contention that, for me, the fun of making art all but disappeared. I felt alone, seesawing between these "departments" that seemed to me like they should merge.

Here's the absolute worst thing you can say to the head of a graphic design department: "An extra year? Oh, come on. It's only graphic design! It's not like engineering. A building's not going to fall on somebody's head because I missed half a semester." The Head said, "Now we won't let you back at all." I was effectively kicked out of graphic design. There was nowhere to go but Painting, where no one was minding the store anyway, and I had time for a few graphic design electives.

I was young and insecure. Now I'm old and insecure. It's ever so much better.

I've pursued all three pursuits ever since, with happy results. Like the sublime, sweet, and salty taste of a Reese's Peanut Butter Cup, graphic design, illustration, and painting (and writing, and comedy) could live in peace and harmony together!

For some people, goals are clear, and the passionate pursuit of one's chosen vocation is a joy. For others, if you get your MBA and then go on to become a banker, it feels like there's something missing. In that case, I'd say, risk it all—try the opposite ... maybe add an unlikely subject— another string to your bow. There's no harm in that.

I'm sixty-six, and I still haven't picked a major.

CHAPTER 13
It's a Canary Because I Say So!

The Power of the Wrong Thing, or the Thing That's Missing

I took a piece of black paper.

This is a story about not doing what everybody else is doing, which seems worthwhile in a world where some people have 8.9 million followers on Instagram. Jiff Pom has 8.9 million followers.

Jiff Pom is a Pomeranian.

I had to draw a canary for my children's book: "And to name but just a few … red, yellow, green, blue." So, like everyone else on Google Earth (formerly known as planet earth), I went to Google Images and googled "canary" and, Hey, Presto! Out popped a flock of bona fide canaries in full, factual, feathery detail.

Doing what every other Googler on the planet does would guarantee me this result: a realistic, believable bird. With these infinite number of reference images, I could easily draw one. Finding the correct color, the classic proportions, is the sensible thing to do. After all, I am a professional illustrator. I'm pretty good! Now I'm ready to draw a most excellent canary.

But I didn't do that.

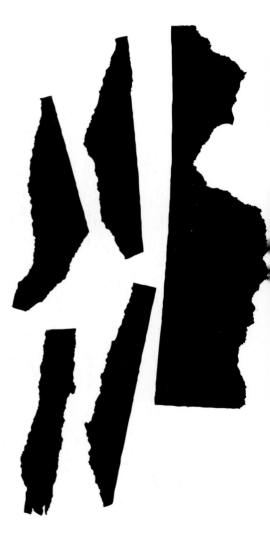

I ripped it to smithereens.
They looked like this.

Then, I chose one smithereen* at random,

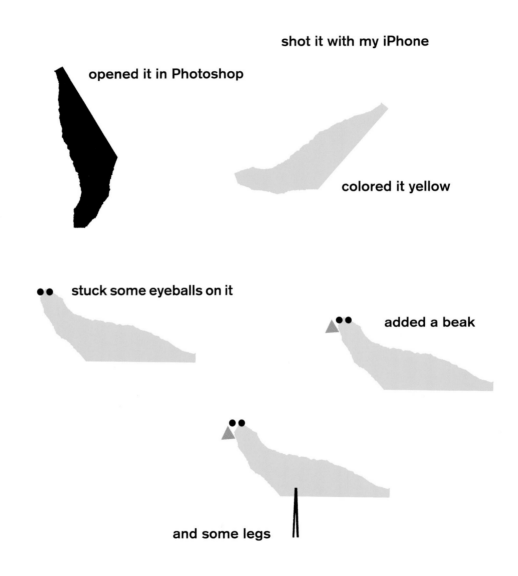

shot it with my iPhone

opened it in Photoshop

colored it yellow

stuck some eyeballs on it

added a beak

and some legs

* (I have an excellent imagination, but this thingy doesn't look any more like a canary to me than the Metro-Goldwyn-Mayer lion looks like Jon Bon Jovi.)

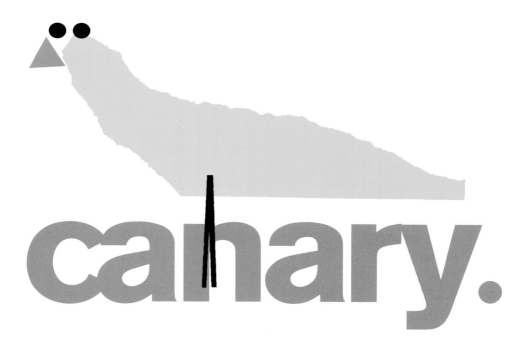

canary.

and—this is essential—put the word CANARY in six-hundred-point Berthold Akzidenz Grotesk Bold under it, and you'd better believe it's a mothertruckin' canary. *You'd better believe!* That's important.

There is a satisfaction in convincing someone of your idea—*forcing* them to meet you *more* than halfway—and to use their own imagination. It's the reason the most brilliant books, films, or TV shows like *The Sopranos*, *Killing Eve*, or *The Wire* win us over, because the basic ingredients are supplied, but no more. The dinner is cooked in an individual's private brain. More

mediocre offerings based on tested formulae serve it up and chew every mouthful for us. But we know what's *not* there is as important as what is. In demanding thought from the audience, you *engage* them. That challenge—withholding something—*turns a passive viewer into an active participant.* Those blank spaces, like those in a tough crossword, are a gift, a tantalizing amuse-bouche to what Hercule Poirot calls "zee leetle grey cells."

This useful approach applies to *everything*—it's not just, um, for the birds. This very power is exactly what helps you to zag.

CHAPTER 14
Giotto's Big O

We are all a product of our times. After all, Michelangelo and Leonardo da Vinci shared the technology and culture of fifteenth century Florence. And Giotto had his Florence of the fourteenth century. That he designed the campanile of the Florence Cathedral, we know.

But Giorgio Vasari, in his *Lives of the Most Excellent Painters, Sculptors, and Architects*, tells the following story about Giotto, which I choose to believe because it conveniently illustrates my point.

Pope Benedict XI sent his messenger to all the best painters, including Giotto, asking for a sample drawing to demonstrate their artistic chops for a major mind-blowing commission.

Right in front of the messenger, Giotto took out a sheet of paper and a pen dipped in red ink and instantly drew a perfect circle, saying, "This is more than enough! Send it with the other artists' submissions, and see if it will be understood."

Feeling like an idiot, the messenger said, "*Really, dude?* Is that it?"

Now that's chutzpah! Or whatever chutzpah is in Italian. *Impavidità! Grinta?*

Anyhow, the messenger delivered the circle, along with all of the other artists' complex, detailed, intricate drawings to the pope, who, when he learned how quickly and easily it was drawn, without a compass, was convinced. Clever pope. Giotto got the job. Kudos,* *amico mio*! Now that's what I call a pitch.

Truth be told, I am not really sure why the skill of drawing a perfect freehand circle, in all its minimal simplicity, would necessarily prove he had what it takes to tackle the majestic Arena Chapel. *It just does.*

* By the way, what is a kudo, exactly? And why do they never travel alone? It sounds like a yummy snack that has yet to be invented. Maybe something salty, but with chocolate?

Americans, in particular, feel that the closer something resembles reality, the more value it has. Pablo Picasso didn't come from Chadds Ford, Pennsylvania. Andrew Wyeth did.

I was utterly gobsmacked when one Japanese client suggested to me, "Can't you make it more abstract?"

Ironically, in Western culture we seem to value pieces that are detailed, intricately worked, and take a long, tortuous time to achieve. And although a camera shot takes a nanosecond, the resulting image is "realer" than any drawing. Thus, illustration will always run a distant second to photography.

That is why clients routinely pay triple the page rate for photographs versus illustration. Once when I was jonesing for more money for a drawing, the client* said, and without any shame, "But that's almost as much as we pay for a photograph!"

That story I can relate to. Yes, I am skilled at drawing because I've made thousands of drawings. I draw almost daily. Making tons of quick and daring darlings, *all but one destined for the chop.* True, in one sense quantity over time can *create* quality. In other words, "practice makes perfect." That's why you want a doctor with many years of experience, right?

Quick and Sloppy Wins the Race

Okay. *Except perfection is not what I'm going for;* what I want is the careless, breezy *high* of working fast, making tons of stuff with a kind of disdain for your own ephemeral, trashable product because you're too busy enjoying the process of producing it. *And that happy, lighthearted feeling will show in the single drawing, recipe, product, or idea you don't throw away.* If a result is any good it's not because it was carefully, slowly, painstakingly made. Results, to me, are never precious. I don't even like that word. What really has great value is your enjoyment. *The fun of it.*

I always know when that "work high" is upon me—because I forget to eat.

* Clients are a type of creature, anatomically similar to humans, except for the large metal plates in their heads. If they don't ask you to change things, if they don't refuse your first, best efforts, they haven't earned their salaries.

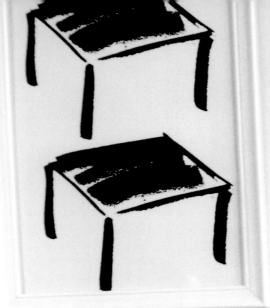

I was teaching the "Mistakes" workshop at Beckmans College of Design in Stockholm. As usual, the drawings piled up fast and furious … hundreds

and thousands of them. None took more than nanoseconds to draw. I grabbed a random few and put them into IKEA frames, just to make a point.

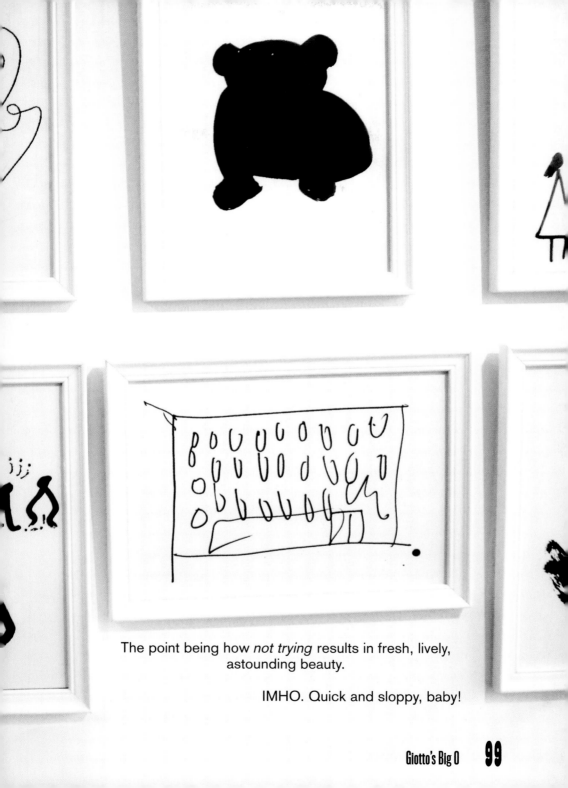

The point being how *not trying* results in fresh, lively, astounding beauty.

IMHO. Quick and sloppy, baby!

CHAPTER 15
Quantity over Quality

Sometimes it's just a numbers game.

Here's an office worker. Let's call him Egbert. He is spectacularly ugly. Short, fat, and bald. He has bad skin and an embarrassing stutter.

His coworkers notice that every day Egbert would be seen around town in the company of beautiful women, going out for drinks, having lunch.

He was having the time of his life! Nobody could understand it. The workers draw straws. The loser has to ask Egbert his secret. Egbert just laughs and replies, "Hey, I know I'm no oil painting. But here's the thing: every single day I ask one hundred women."

Start thinking Quantity, not Quality. Think anything but Quality.

One of my childhood's most influential, um, influencers was painter and bare-foot socialist party girl Roz Roose. She'd often turn up at art exhibitions, warmly embrace the artist, and shout, "Kisses! Kisses on your opening!"

Of course, this greeting is more effective somehow when the artist is female. And it was invariably Roz who I turned to in my darkest moments—she reminded me that bad things happen to us all, quoting the allegedly diminutive statesman and military leader we all know and love.

> *Defeat! Defeat! Defeat! Defeat! Defeat!*
> *Defeat! Defeat! Defeat! Defeat! Defeat! … Victory.*
> —Napoleon Bonaparte

I can't remember how many times she repeated it. Enough. It turns out my treasured memory bears zero relationship to the truth. Because Napoleon won way more battles than he ever lost.*

Roz's daughter Gina never heard her say it, and for all I know Roz said it to me alone in a fever dream. I don't care. If an anecdote successfully serves one's purpose, all hearsay shall hereby be regarded as gospel. Merci beaucoup.

Notably, "Le Petit Caporal" was also cited for this gem: "Women are nothing but machines for producing children."

I like to show both sides. Particularly insofar as Old Boney is concerned. Besides, emperors of France are not particularly renowned for their sensitivity to gender issues.

* Napoleon Bonaparte measured a respectable 5 feet 7 inches, an above average height for men in the nineteenth century. History shows he repeatedly made the stupid mistake of standing right next to his Imperial Guards, a group of unusually tall men. It was the British who let "the Napoleon Complex" rumor get around, having a well-known *boeuf* with the French also known as the Napoleonic Wars.

Maybe try: If there's something you really want, try a hundred times to get it. Did you write the great American novel? Superb! Now aim for a hundred rejection letters. Trust me—it **can** be done.

The Giotto Circle Story Except More Chinese and with a Rooster

A Chinese emperor invited a Sumi-e (brush painting) master to paint a rooster for him. The master said, "Sure! No problem. I will be back in ten years." The master returned as promised ten years later and right before the emperor's eyes instantly painted a rooster. A masterpiece. The emperor said, "Wait a minute, I'm paying you all this money, and it only took you ten seconds!"

The master said, "Well that's true — but you haven't seen the ten thousand roosters in my studio."

Years of training do not guarantee a great artist, doctor, or anything else. However, the surgeon, the pastry chef, the politician, playwright, electrician, and the football player all experience that confidence, ease, that "in the zone" *feeling* that only repetition over time can bestow. There is no substitute for this.

Let's get all Zen. One Hundred Darlings.

At its best, Sumi-e painting displays what I consider a higher calling than representation. Artists like China's Qi Baishi (1864–1957) go way beyond mere depiction and right to the soul of something, based not upon realistic detail, but upon discovering the very essence of a thing. This idea is as Zen as you can get.

You don't want to kill your darlings? Too bad. Careful? Cautious? Try quick and sloppy. Make one hundred darlings and trash ninety-nine of them. Do a whole raft of stuff in a big, sloppy hurry. Try this. Try that. Now try it ninety-nine more times.

Work as fast as you can. Continue with great carelessness. In the live (or Zoom) HTMMOP workshop we draw, but it doesn't have to be drawings. Your darlings can be movie titles, dating profiles, applications, architectural renderings, chess moves, cupcakes, paragraphs, mathematical equations.

In more than thirty years of teaching the "Mistakes" workshop, I have seen bank managers, executive chefs, medical students, real estate agents, librarians, writers, and contractors who never, ever draw, make the most exquisite, exceptional drawings imaginable. And this is the key: because they see right away that results don't matter, nobody's looking, there is never a critique or any commentary — they're just having fun.

Maybe try: Put on some loud dance music—or whatever kind of noise you like. Draw a whole bunch of red circles (freehand) quick and sloppy, as fast as you can. Draw a hundred! Look at them. Have a think. I bet the ones you drew fastest and sloppiest were the bestest.
Then trash them, burn them, flush them, frame them, dip them in platinum. Whatever! I'll bet they're beautiful and 100 percent imperfect. Like we all are.

CHAPTER 16
Make War, Not Love

Conflict and creativity go together like … peanut butter and chocolate. Trouble and violent adversity make things sizzle.

I took a well-known screenwriting seminar called "Story" with Robert McKee. The attendees watched *Casablanca* over seven grueling hours. Every moment was picked apart, but what resonated most was McKee's interpretation of the movie's underlying theme, taken from classical literature: Being and Becoming.

beco

Being: Endless childhood, where all our desires are satisfied. Like a gurgling, well-fed baby, with no responsibilities. We see the happy pair, Rick and Ilsa, together in Paris. Being human, being in love. Sweet.

But what kind of movie would that make? We're not watching these happy lovebirds moon over each other for two hours. We need some kind of conflict. How about World War II? As conflicts go, you can't beat that.

Becoming: Adulthood. Our difficult part to play in this great big world. Doing things you don't want to do, for the greater good. For a rewarding movie, we need tension. Here, the choice between freedom and sacrifice drives the story. McKee thinks the song "As Time Goes By" perfectly encapsulates this idea in the lyrics, "It's still the same old story, a fight for Love and Glory." Not Love *or* Glory. Love *and* Glory. Being *and* Becoming. Painful compromise as dramatic hero? That tussle is what makes a fine movie and an interesting life. Play it, Sam. It's their song, but isn't it everyone's?

Love. Ilsa wants Rick, but in the final scene, her duty is to leave Casablanca, to accompany her husband, resistance hero Victor Laszlo, instead, and stand by him in the fight. Because his work *matters.* As Rick says, "The problems of two little people don't amount to a hill of beans in this crazy world. ..." Besides, in the end, "We'll always have Paris." The memory of their happy, selfish, wonderful love. Their Being.

Glory. Sacrifice. Getting on that plane with Laszlo. *Casablanca* is a fight for *both.*

Without conflict and tension *there is no story.* For a third act denouement you need the second act of calamity, or disappointment at least.

You need it like the turkey needs the axe.

One of my favorite writers is Stevie Smith. In *Over the Frontier* (1938) her protagonist, Pompey, joins the British Army during World War II, and "thanks the God of War to be rid of tea-cups and tattle and the boring old do-all nothings of a finished existence."

In my view, Pompey's gratitude for the war was in finally knowing exactly the right thing to do, and that her actions were important, far beyond girlish gossip. She had been deadly bored and found happiness and freedom in conflict.

Our version of teacups and tattle? We drink red wine and cappuccini and download stuff and stream stuff. We watch, we listen. Facebook fatigues. Twitter's tedious. Things aren't so special anymore, are they? Go ahead, take another selfie. Our contributions are virtual. That means *not real.*

Our digital life is squeaky clean, full of easy leisure and empty pleasures. When I see a person who obviously spends countless hours at the gym, I feel nothing but pity for them—to me it looks like proof of a wasted life. And I'm sure they'd say the same about mine if they could see all those paintings in my basement.

A war, a pandemic, reminds us how little control we really have over anything. We will suffer, it is our fate. The day we can't feel pain, we are no longer human.

WHAT'S THE WORST? THAT COULD HAPPEN

Nothing to try. No recipe for catastrophe—it is to be studiously avoided, but can't be. I write this in the middle of the COVID pandemic. It's horrific. I cannot see into the future. But like all disasters there **will** be a turning point, a precursor for big, big change. For transformation.

CHAPTER 17
Pacifism ... the Hard Way

Disaster Is Dynamite

What's it all about, Alfie?

Dateline: Stockholm, 1864

While experimenting with ways to stabilize the explosive nitroglycerin, Alfred Nobel learned pacifism the hard way.

After his laboratory workers experienced many near-fatal accidents, one experiment killed Nobel's beloved younger brother and several others. This may have pushed him to find a way to store explosives. This he discovered through yet another accident.

Nitroglycerin cans were packed in kieselguhr for transport. One of these accidentally cracked open and leaked. Nobel developed a formula *mixing* kieselguhr and nitroglycerin, which turned the scary goop into a stable solid without removing its

power. He wisely patented this in 1867, naming it dynamite, which revolutionized not only the construction industry, but also destruction, deadly weapons, and warfare forever. Not to mention twentieth century urban television slang.

Dyn-o-mite!

His lucrative contribution to violence was distressing to him—so much so that Nobel was moved to gift humanity with an enduring prize, to be awarded to those who promote world peace.

Maybe try: What reprehensible, selfish, stupid, and destructive thing have **you** done? Great! The more unforgivable it is, the better its chances of bringing you great power, success, and wealth. Now, with these top-notch material advantages, you too can achieve near sainthood. Do something spectacularly kind and generous, **out of pure guilt.** Your questionable reputation being what it is, let's just say **it couldn't hurt.**

What's the worst that could happen?

How to Make Mistakes on Purpose

CHAPTER 18
Vox Populi Knows Better Than You Do

Let's get this part over with. As we all know, corn flakes were supposed to prevent wanking.

Anti-masturbation dieticians (I wonder—was that on their business cards?) Dr. John Harvey Kellogg and William Keith Kellogg were followers of Ellen G. White and Sylvester Graham, who believed in eating only bland, tasteless foods to prevent sexual arousal, and gave us that chastely perforated marvel, the one-and-only graham cracker.

Claiming that in "masturbation-related deaths" a victim literally dies "by his own hand," J. H. Kellogg decided to circumcise himself at age thirty-seven.

To prevent the "solitary vice," he recommended electroshock, binding children's hands, covering their genitals with patented cages, and applying carbolic acid to, or removing, the clitoris.

"A remedy that is almost always successful in small boys is circumcision ... the operation should be performed by a surgeon without administering an anesthetic, as the brief pain attending the operation will have a salutary effect upon the mind, especially if it be connected with the idea of punishment."

You okay? May I continue?

When John Harvey Kellogg's *Plain Facts about Sexual Life* appeared, he was single, but he and his bride added another 156 pages during their honeymoon, ending up with a 900-page doorstop. About a half-million copies of *Plain Facts* were sold, door to door.

A half-million. That's a lot of Fake Facts. I have a funny feeling that the numerous scions of these unlettered cretins are responsible for the recent attempts to annihilate American Democracy–and a good reason why public school teachers should be paid like celebrities and corporate executives.

These disturbingly prudish gentlemen were looking for a predictably dull substitute for the devil's own liquid—deep, dark, sensuous coffee—first experimenting with grain.

According to Wikipedia, Kellogg's (now rebranded as the Original Plant-Based Well Being Company) website, and local gossip, one day they left a batch of wheat unattended (I wonder if this counts as animal cruelty) to go do something else—possibly to masturbate. When they returned, the wheat was stale, but they rolled it out anyhow, and *voilà*! A flat, thin flake.

They toasted the flakes, which were a big hit with patients. Ladies and gentlemen, I give you—Wheaties! They patented the process, then experimented with other grains, including corn, and in 1906, Will created the Kellogg's company to sell corn flakes. The rest is breakfast history, up to and including Kung Fu Panda Crunchers, Bamm-Bamm Berry Pebbles, Jurassic Park Crunch, and Donkey Kong Crunch, culminating in the most terrifying bowlful of all—Kashi Indigo Morning. It's a slippery slope.

What can we learn from the brothers Kellogg? Just this: they must have realized, during their spectacularly abstinent and tedious lifetimes, that *there's a whole lot more financial success in corn flakes than in forced circumcision.* Thankfully, nowhere near as many people succumbed to their cruel and idiotic practices as enjoy Sugar Smacks, Rice Crispies, Special K, Cracklin' All Bran, and Raisin Bran. With two scoops!

In case you were wondering, Kellogg's also invented Banana Bubbles, Bart Simpson's No ProblemO's, Eat My Shorts, C-3PO's, Chocolate Mud & Bugs, Homer's Cinnamon Donuts, Fruit Twistables, Crunchy Loggs, Mr. T's Muscle Crunch Krumbles, Cocoa Hoots, Puffa Puffa Rice, Razzle Dazzle Rice Krispies, Yogos Rollers, Product 19,* and Zimz.

So, whatever your initial passion, your heartfelt reason for an achievement, if it veers off in an unexpected direction because people happen to like it, don't be too proud to go along with the program.

I have learned through bitter experience that I myself am a reasonably talented, feeble-minded nut job with obsessive-compulsive disorder and the business acumen of a eukaryote.

If you can just give in and admit that you, too, might be an incurable fanatic with a blind spot the size of Antarctica, and that **the vox populi knows much better than you do,** *all this can be yours.* Just think about the circuitous route that led to the crunchy, delicious miracle that is Frosted Mini-Wheats. Not to mention Cinnamon Marshmallow Scooby-Doo, Apple Jacks, and Barbie Multi-grain.

Of course, the Kellogg brothers are lovingly remembered today as beneficent breakfast saviors and not as maliciously cruel mutilators of small children. How would you like to be remembered?

Alfred Nobel turned his Olympic-level guilt into a force for good, and so can you.

Maybe try: Very few ideas ever become global, go viral, or make big money. If you are lucky enough to be noticed, yield to popular demand. You might have another $412.6 million in Froot Loops yearly sales on your hands. If they're not tied behind your back.

* I always thought Product 19 sounded way cool—a bit like Soylent Green, but made of corn instead of … corpses.

Scott Menchin

CHAPTER 19
Get Lost on Purpose

My Fellow Amerigos!

Greetings from America, my home continent, where making Mistakes is a way of life!

America is named after Amerigo Vespucci, the Italian explorer who proposed the revolutionary concept that the lands that Christopher Columbus sailed to in 1492 were part of a hitherto unknown fourth continent, and not part of Asia, Europe, or Africa. Brazil was also bumped into by chance, by one Vicente Pinzon, who sort of overshot the West Indies.

The Most Beautiful City in the World

My friend Scott Menchin thought he had discovered the most beautiful city in Europe. He fell asleep on a train (which he was sure was heading toward Germany), woke up, and walked out of the train station to be floored by a great-looking, mysterious city. He walked to the river and noticed a map of the place. It was Paris.

Isn't that a fun story? Siri—that spoilsport—Waze, or Google Maps would have cheated my friend Scott out of a miraculous moment he remembered so fondly more than thirty years later.

In fact, I have an embarrassing anecdote I'd like to share. Place: Gothenburg, Sweden, 2012. Dramatis personae: Laurie, Michele, and Pierre. Michele was driving us all in the big grey VW van. I'd decided it would be fun to get lost on purpose, a chance to act upon HTMMOP principles, and the others agreed to try it. Unfortunately, I'd chosen what turned out to be a nondescript neighborhood, what New Yorkers would call an outer borough, to get lost in. We walked

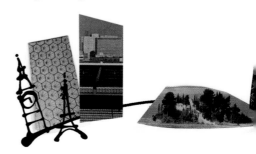

along the road, into and out of some parkland, and there was the van. We turned around and walked the other way, came out of a playground and there was the van. We headed in a different direction, but as it was getting cold and dark, because that's how things get in Sweden, and I was feeling cranky, I said, "Never mind—I want to go home, this isn't working."

So we turned right around. But where the van had been just a moment ago was a parking lot we'd never seen before. We ended up wandering around what was really a housing project for the next three hours, arguing with each other. Finally, we had to hitchhike and eventually located the van in the exact spot where we had left it. What did we learn from this?

You will not meet the locals if Yelp has told you exactly where you can meet the locals. Here's a simple solution if you really want to discover something for yourself. Wander around and look at stuff.

But as any knowledgeable, skillful, expert, accomplished, adept, adroit, master, consummate, professional, proficient, trained, competent, capable, qualified, well-versed, seasoned, practiced, mature, veteran, long-serving, time-served, hardened, battle-scarred, crack, ace, wizard traveler who makes profligate, promiscuous use of thesaurus.com will tell you, neither will you—and this is guaranteed—experience a horrifying, horrific, dreadful, awful, frightful, terrible, horrible, scandalous, outrageous, disgraceful, vile, abominable, ghastly, foul, monstrous, hair-raising, explosive, knife-edge, cliffhanging adventure such as …

Anders Wenngren

How to Make Mistakes on Purpose

The Vegetarian Burrito I Will Never Forget

"I remember when food was just food." This was the gag line for a *New Yorker* cartoon depicting a couple chatting at a restaurant table. Another cartoon showed a worried waiter, inquiring of same couple, "What's wrong? You haven't photographed your lunch." These cartoons may have existed only in my mind. But I think it really was *The New Yorker*.

I am sick and tired of being served food that is invariably fresh, clever, delicious, and artful! In fact, mediocre, unappetizing food is so rarely experienced by us fortunate, entitled snobs that it comes as a refreshing surprise.

I was hanging with my students from LHI, the Icelandic Academy of the Arts, at a Mexican restaurant in Reykjavik. I ordered a vegetarian burrito. It arrived a short time later: a sad flour tortilla *containing a large, rectangular ice block of frozen French fries, unthawed,* and *nothing else whatsoever.*

We couldn't believe it! We laughed uncontrollably—like lunatics.

Now, I wouldn't wish that dinner on anyone. Well, not to eat—but so much fun! But Myrra, Jorri, Raggi, Pétur, Arnór, Ásdís, Frosti, Guðmundur, Hreinn, Snorri Þór, Rán, Björgvin Óli Friðgeirsson, and I were simply delighted—enchanted! How often, in our exquisitely mundane and bourgeois existence, does that kind of story unfold? A truly memorable occasion. And one that Yelp and the like would have cruelly prevented.

Maybe try: It's hard to get lost on purpose, but do try. It just might give you a glimpse of something utterly unexpected and new, **that nobody else knows.** Isn't that worthwhile? If you invariably stick to Yelp, Trip Advisor, Google Maps, Siri, and their myriad and reliably predictable offspring applications, it's a sure thing you will enjoy a decent pizza, sleep in a clean hotel, swim in the same pool with other practical Yelpers and well-Advised Trippers **exactly like you.**

CHAPTER 20 Misdirection

It's not where you think it is.

Here is a collage created by a nine-year-old girl named Vida Behar.

In the center there's a huge, traditional rainbow, with, unsurprisingly, a pot of gold at the end. Right by the pot of gold, there's a headline that reads, "You never find anything good here."

But way over near the picture's edge, a good bit away from the rainbow, there is a tiny blue blob. Another headline reads, "This, however, is worth it." It points with an arrow toward the little blue blob. Vida gets it.

It's helpful to think about the idea of misdirection, the jiggery-pokery magicians use. The audience is intently focused on his sleight of hand. A card is produced from … where? The place where we weren't looking. If we focus on the real action, the magic disappears.

Instead of focusing on a problem to solve it, do something careless, pointless, something … way over there.

it's all About MisDiRection.

oops!

you think its all happening here →

look! ←

but really its happening here ↓

Maybe try: What are you trying very hard to do? Try giving that up—at least for a bit. Where are **you** not looking? It's never where you're looking that the treasure lies.

CHAPTER 21
That's Not the Rashomon I Remember!

The Lincoln Arcade Building
1137 Broadway, New York City

Did my dear father, Robert Lessing Rosenwald, a.k.a. Daddy, Bobby, and Bob—really burn down the Lincoln Arcade Building with a Pall Mall? He was always bragging about the fact that he accidentally created a four-alarm fire that consumed the entire block and cleared the way for Lincoln Center. He was a failure, a drunk, an irresponsible loser. We owe him much.

Bob did have a sculpture studio there in the 1950s, but Google disillusions me. According to them, the Lincoln Arcade Building burned down in 1931, was rebuilt, and was eventually bulldozed in 1959 to make way for the Julliard School. No '50s conflagration.

Yeah, right.

My information may be flawed, but I do remember that studio, and, at three years old, being lowered naked into an enormous canister of greasy, olive-green plasticine, a malodorous clay used to make bronze castings.

He left me in there to play for a while. That was his idea of babysitting.

Lovingly nicknamed "The Dog Kennel," 1137 Broadway was a ramshackle, five-story rabbit-warren of shops and studios located on the west side of Broadway between 65th and 66th streets.

Tenants included a theater, a bowling alley, detective agencies, milliners, dressmakers, jewelry stores, a dance studio, dancers, dentists, lawyers, and a mind-blowing lineup of artists like George Bellows, Raphael Soyer, Neysa McMein, Marcel Duchamp, William Glackens, John Sloan, Alexander Archipenko, and Thomas Hart Benton. Robert Henri held classes there for Stuart Davis, Rockwell Kent, and Edward Hopper.

Eugene O'Neill and William Powell rented space, and Alfred Lunt and Leslie Howard took drawing lessons from Soyer. John Barrymore rented a painting studio in hopes of being the great artist, not just The Great Profile.

An art critic once wrote, "The Arcade housed an unsavory crew: commercial artists, illustrators, starving students, musicians, actors, dead-beat journalists, nondescript authors, tarts, polite swindlers, and fugitives from injustice." Van Wyck Brooks said the building was a "rookery of half-fed students, astrologers, prostitutes, actors, models, prize-fighters, quacks, and dancers."

The point is you can't trust Google. I know what I know.

New York's New Bohemia at Lincoln Square.
Sketched for THE NEW YORK TIMES by Louis Rant.

123

CHAPTER 22
There's a Nipple in My Room!

The Amway Grand Plaza Hotel, Grand Rapids, Michigan
vs.
the Whitney Museum of American Art, New York City

The bologna slices are dripping, weeping with glistening fat, "mourning a haunted order, a ghostly category, a soggy practicality, a floppy commonsense," as Pope.L writes in a haunting poem attached to the wall. Over time, the meat slices will curl in on themselves, the portraits will slide off, and the sickening smell of decaying meat, real or imagined, will sit in your clothes for the rest of the day.
—Description of Pope.L's *Claim*, 2017 Whitney Biennial, Whitney Museum of American Art

Out of the blue, I was invited to hold the "Mistakes" workshop in Grand Rapids, Michigan. The client was an investment management firm whose goal was to raise the profile of Grand Rapids as a cool, up-and-coming business destination with a brilliant economic future. And for all I know, this could very well be the case.

A young woman tasked with organizing the event found me by simply googling the word "MISTAKES" and found yours truly. She wrote, "Our theme for the 2017 Summit is 'risk, failure, and the future'—we really want to encourage innovation, collaboration, and risk-taking, destigmatize failure, and inspire our team members to take chances."

That's exactly the kind of language big corporations use when they're getting ready to sell you some top-notch hogwash. Of course, every company, big or small, has an impossibly glowing, utopian mission statement that makes me roll my eyes. And hey—don't we *need* to keep failure stigmatized? Otherwise what's the point?

The workshop was held as a small part of a major weekend event held in the historic Amway Grand Plaza, an elegant old hotel. One hundred fifty smartly attired businesspeople attended my inky workshop. They all donned plastic garbage bags and swore omertà, the Mafia code of silence. I always insist on these two points. It's about surprise, after all. And keeping one's Ermenegildo Zegna power suit as pristine as possible under what might be described as fairly Jackson Pollock–like circumstances.

The participants nervously entered the top-secret chamber of chaos, heretofore known as the Grand Amway Pantlind Ballroom. From the speakers, Ice-T is softly crooning his 1988 megahit, "Girls Let's Get Butt Naked and F—!"

The Amway Grand Hotel's mission statement can be found on its website:

"To be the most admired hotel company by delivering quality experiences for our guests and employees."

Very well. I get that!

I live in a bubble, avoid Fox News, and thus have never seen so many right-wing Republicans in one place. Not in real life!

As usual, I was spending half the year in Sweden, but they flew me the five thousand miles business class, paid a hefty per diem, and $10,000 for a forty-five-minute workshop. On the check it said "Failure Lab."

Here is that check.

Onward!

I arrived at my palatial, spectacularly neutral suite at the legendary Amway Grand Plaza Hotel, apparently a jewel in the crown of whatever "The Curio Collection by Hilton" might mean. I have never before seen such subtle variations, which ran the gamut of bland tonality from off-white to ivory. As recompense, perhaps, with an ecru nod to quirky ingenuity, the postmodern teabags were pyramidical, with a tiny green leaf for a tag. The oval bath soap had an oval hole in it. WOWSERS! I kept it.

That's the kind of tortured effort that provides corporate luncheons with Crayolas that never get used. Naming your conference rooms "Tupac," "Bowie," "Turing," and "Kubrick" will not help, either.

There were two king-sized beds, each with no less than six Brobdingnagian pillows. My picture windows looked over the majestic Grand River toward the city center and the fabulous Gerald R. Ford Presidential Library and Museum, with its teeming archives of vital material on domestic issues and foreign relations during the Cold War era, focusing on the Ford administration, and the saucy, salacious papers of Betty Ford, first lady and savior of substance abusers.

There was a nipple in my room.

I hadn't been prepared for that. I mean, this wasn't Hooters, the David Zwirner gallery, or the Whitney Biennial, "Where nipples are just the beginning!" (I made up that tag line. What do you think?)

Full disclosure: okay, the title of the nipple artwork said "Tumbleweed" in the corner, so I'm guessing that whoever chose this pink and stimulating piece of Hilton décor wasn't specifically looking to display areolae.

For those of you who are not *au fait* with the Whitney Biennial, from the museum's website, here's a juicy "titbit":

"Key issues and approaches emerge across the exhibition: the mining of history as a means to reimagine the present or future; a profound consideration of race, gender, and equity; and explorations of the vulnerability of the body. Fundamental to the Whitney's identity is its openness to dialogue, and the conversations that have occurred here and across the country became a productive lens through which to synthesize our own looking, thinking, and self-questioning."
—Verbatim, if you can believe it.

Now, for all I know, these pretentious eggheads might have been saying the very words I have in my mind: *Context is everything.* That's why I was delighted, nay, *over the moon* to find a nipple in my room.

There's a Nipple in My Room! **127**

Calling All Paint-Splattered, Post-Porn Picture Makers!

John Currin and Lisa Yuskavage, eat your well-upholstered, arty hearts out. Because the Grand Amway's *titillating* "Tumbleweed" just blew you beloved Biennial babes completely away.

The *Village Voice* newspaper had a terrific campaign in the '60s, designed by Tomi Ungerer: "Expect the Unexpected" was the headline. *But I didn't.* In these conservative, hidebound surroundings, I most definitely expected the expected. I wasn't expecting to be struck dumb in downtown Grand Rapids.

A surprise is so rare in the art world. In fact, it's the *last* world where surprises can happen. Because it's trying so very hard to shock us.

I submitted a photo of the nipple *in situ* to the prestigious Grand Rapids ArtPrize* and wrote several emails to prominent members of the East Coast Media Art Elite, extolling the Amway Grand Plaza and its daring explorations of the "vulnerability of the body."

Did *every* visitor to that room see the nipple on the wall?

Well, they should have. *Because it was there.*

To illustrate my meaning, read this bit from my favorite Thurber story, "The Little Girl and the Wolf":

She had approached no nearer than
twenty-five feet from the bed
when she saw that it was not her
grandmother but the wolf,
for even in a nightcap
a wolf does not look any more like
your grandmother than the
Metro-Goldwyn lion looks like
Calvin Coolidge. So the little girl
took an automatic out of her basket
and shot the wolf dead.
—James Thurber (1939)

* I found out later that my same reactionary hosts sponsored this competition, too. It is doubtful if they would have bestowed their top-notch Christian cultural kudos upon "Nipple Surprise" or "Grand Amway Arousal."

Maybe try: Pretend you are a Martian
visitor to Earth. You have just had a very
successful Lasik operation.
Don't be naïve. Know what you know.
Trust what you **really** see,
no matter how preposterous.
And trust your own taste, too.

MP3

EMAIL

PILATES

NETFLIX

GOOGLE

BABIES

TINDER

ESCITALOPRAM
OXALATE

humming

YELLING

WASHING DISHES

BBC ONLY CONNECT
ON YOUTUBE

THINKING

GLASS-TOPPED COFFEE TABLES

WINKING

CRYING

My idea of an interesting person is someone who is quite proud of their seemingly abnormal life and turns their disadvantage into a career.

● ● ● ● ● ● ● ●

It wasn't until I started reading that I discovered you could be insane and happy and have a good life without being like everybody else.

— John Waters

CHAPTER 23
The Emperor's New Nudity

Remember Bluebeard. If some hunky and well-dressed fairytale dreamboat with a blue beard and an ostentatiously plumed hat goes around murdering your sisters and hanging their bloody corpses from hooks in a forbidden underground chamber, *you really should say something.* Yes, even if he's a handsome, wealthy, and popular nobleman. Dare to see the emperor's new nudity. And then go tell everybody about it.

Not Fashion. Stripes.

I've been wearing stripes nearly every day since birth. I shop by googling "WIDE RED WHITE STRIPES" size XL under $35. I've always known *exactly* what I like. I do not give a fiddler's fart about fashion, or designers and their idiotic labels.

We are all designers. That's what scissors, Sharpies, duck tape,* eyeliner, spray paint, Photoshop, and eBay are for. I do not need a mood board to tell me the lay of the land. Why would I care what other people do? I yam what I yam, and I suspect you are, too.

* Yes, it's duck, not Duct, invented by a female factory worker and made out of cotton duck.

They (whoever "they" are) just don't make very plain cobalt blue leather boots. They simply do not exist. I wanted some. So I splashed out an Alexander Hamilton on Krylon Cover Maxx Global Blue Gloss Spray Paint & Primer, and … abracadabra! Here's one on my blue painted floor. I like blue. Okay?

When I get compliments on my footwear, and I often do, people are surprised to learn that I paint my shoes with spray paint, or order custom Vans sneakers online, which I design and they produce.

What I don't understand is why *everyone* doesn't make things look how they want them to be.

Maybe try: Trust your goofy ideas. Write them all down. Or record them on Voice Notes, it's handier. Unless you are being talked down off a ledge, you don't have to follow influencers. Cultivate individuality, rabid or otherwise. Hang on to it like grim death.

I have a friend, let's call him Cyrus, who is justifiably proud of waking up very early in the morning. He enjoys drawing crows, as well. I have another friend, let's call her Lene, who makes cozy little sweaters for all her coat hangers. If it is a natural proclivity, being a clean and sober citizen "washing one's clean linen in public" can be a *thing*, a mark of singularity worthy of special mention just as much as being an insurrectionist firebrand with face tattoos and a neon fright wig. Which is so cliché.

No. What's authentic is quite often invisible to the hoi polloi. On the other hand, if the road less traveled leads straight to Nowheresville, you can switch gears and …

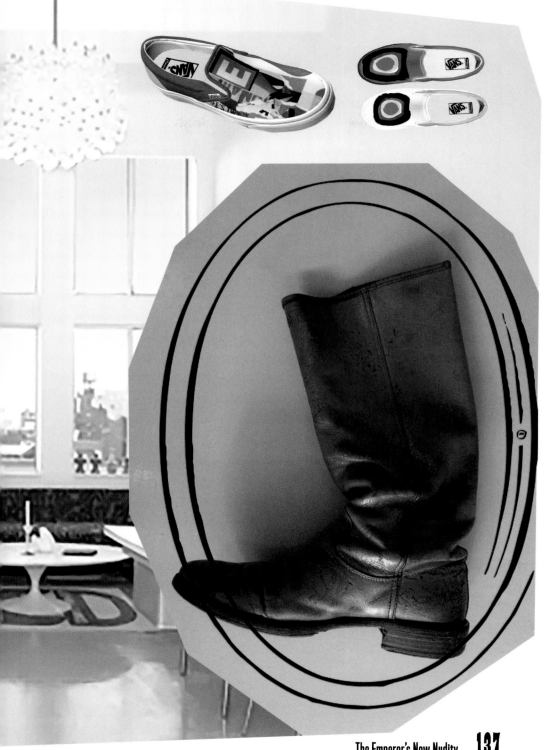

CHAPTER 24
Do the Opposite

This *Seinfeld* episode takes place in Monk's Café, as per usual.

George confides to Jerry that his life has turned out to be the opposite of the life he'd wanted; that every decision he's ever made, every instinct he has, has been wrong.

A waitress writes up his usual order of tuna on toast and a cup of coffee. But because his decisions have always been wrong, he chooses instead "the opposite" of tuna on toast, boldly ordering chicken salad on untoasted rye and a cup of tea.

Elaine notices that an attractive blonde has been looking at George and encourages him to make a move, but George points out that "bald men, with no jobs or money, who live with their parents, do not approach beautiful strangers."

Jerry dares him to try the opposite. **Not tuna salad and intimidation, chicken salad and going right up to them!**

Because if George is always wrong, the opposite action just may be right. George approaches the blonde and introduces himself. It works like a charm.

Hi. My name is George. I'm unemployed and I live with my parents.

Maybe try: Who do you usually see? Who's the opposite of them? What do you usually do? What's the opposite of that? Where do you usually go? Where's the opposite of that?

I'm
VicToRia, Hi

How to Make Mistakes on Purpose

Or, if not the opposite, maybe …

Right Next Door to Mister Right

A woman goes to a party. She is single and at once notices an attractive man standing by the bar. She would like to get to know him. But wait. Why is this lovely woman single, anyway? Because she's never had good luck with men! She's always attracted to good-looking guys who turn out to be selfish, narcissistic creeps. Fortunately, she's just seen the "The Opposite" episode of *Seinfeld*.

Déjà Vu All Over Again

She *knows* that she doesn't know how to pick 'em, so she tries something new. Standing just to the right of the handsome guy she espies a rather ordinary looking man. She hadn't noticed him before. She goes up to him and just says "Hello." He's pleasantly surprised. And happy. Aw, shucks … this never happens to *him*! He buys her a drink. They chat, they flirt. He's witty, charming, kind, and a good listener. He turns out to be Mister Right.

Are you, too, looking for love? And if not, why not? Love is often a thrilling mistake. Or maybe just an alternative answer? A different future?

Maybe try this: Notice a repeating pattern? Well, by all means, break it. Forget that pretty girl next door. She thinks she's the bumblebee's roller skates, the smug thing! Go for the girl next door to the girl across the street. Or her ex-stepsister. Or her mother. Or her brother. Or her father.

CHAPTER 25 Spoiled for Choice

Django and Le Jazz Very Hot

Guitarist Django Reinhardt and his girlfriend, Bella, were at home in their gypsy caravan near Paris. Bella was making fake flowers with paper and celluloid, which is very flammable. Django knocked over a candle. The flowers and caravan burst into flame. The two smallest fingers on Django's left hand were paralyzed.

Because of this, he was able to use the index and middle finger of his left

KEITH JARRETT
THE KÖLN CONCERT

ECM

hand, and had only limited use of his two shriveled fingers on chords, double-stops, and triple-stops when he played, creating an entirely new style of music: hot jazz guitar.

The Wrong Bösendorfer

Cologne's opera house was filled to capacity with more than fourteen hundred people. It was the first jazz concert they'd allowed at the venue, ever. Pianist Keith Jarrett hadn't slept well after a 350-mile drive from Zürich, Switzerland. He was in severe pain from back problems and had to wear a brace. An Italian restaurant was reserved for Jarrett's dinner, but some problem with the waitstaff caused a delay, and he didn't have time to eat.

Vera Brandes, Germany's youngest concert promoter, was seventeen. She'd ordered a Bösendorfer 290 Imperial concert grand piano at Jarrett's request, but the opera house had another Bösendorfer backstage and someone just stuck that one onstage by mistake. It was in horrible condition, untuned, and completely unplayable. It sounded tinny. The pedals didn't work. The right Bösendorfer, the 290 Imperial, was in a distant location. There was a rainstorm going on.

After trying the broken-down piano, Jarrett refused to play, but the concert was scheduled to begin shortly, and at midnight, he finally gave in.

The album of that performance was released in 1975 and became the best-selling solo album in the history of jazz and the best-selling piano album of all time, with sales of more than four million to date.

These are not inspirational stories of "winning" in spite of immense challenges. Oh, no! *Because* of an unforeseeable fiasco, something truly new and revolutionary is found, as if an athlete with a missing limb had invented a brand new sport, one they can perform better than others. That's a whole different box of Skittles!

These days, many of us are spoiled, very much so. The correct, the most sophisticated equipment, the (relatively) good medical care, the *mens sana in corpore sano*. A decent education. Freedom. Although I consider it a boring and pointless pursuit, anyone with the time to excercise is very lucky. *Mistakes* is not suggesting we seek out disaster, trouble, and pain. It is a way to remember how lucky we are. Mostly. And how complacent that might make us.

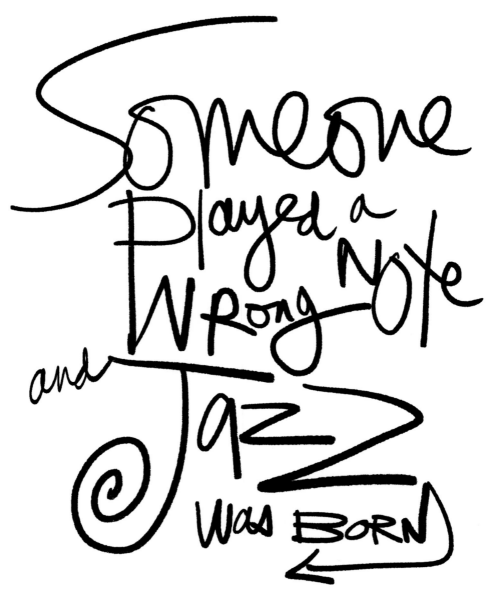

Someone played a wrong note and Jazz was born

—Art Blakey

CHAPTER 26
Amortize This!

Anyone will tell you it's a mistake to leave valuables lying around. Right? Well, it's a mistake I highly recommend.

I'm a bike person, forever. I live in New York City, so my bike is my car. I don't use it for exercise.

I use it to get where I'm going. Once in a while, depending on this and that (laziness, impatience), I don't lock my bike. If I go into a shop just for a few minutes, I take a chance.

I weigh the advantages and disadvantages, the risks, all in a frenzied nanosecond. Lazy always wins.

And then, in my mind … I *amortize.*

Amortization is defined as an accounting technique used to periodically lower the book value of a loan or intangible asset over a set period of time.

I hate locking my bike, because it is a time-consuming pain in the neck. I resent those four minutes, each on either side, to lock and unlock it, for a three-minute errand. I don't understand why if I can watch *Arrested Development* anytime I wish by remote control, and the military can murder thousands of innocent civilians by remote control, why can't there be a bike lock as easy and instant as a remote car lock?

This is key: I have a fairly crappy bike—I buy them used (this means stolen) for seventy-five bucks and run them into the ground. If it does get stolen one time out of a hundred, well, *I'm okay with that.*

I do the same with handbags, suitcases, phones, computers. I "save" my seat at a café with these things and go do something else. I've never had these "valuable" items stolen *this way*, not ever.

So, is this a smart mistake or just counter to perceived wisdom? For a seventy-five-buck loss, I've had years of carefree errands and hours of blissful denial. In over fifty years of worry-free living, I've had exactly four bikes stolen.

Well worth it.

What has value? I say it's my time, energy, and a feeling of freedom spread out over a lifetime.

"For what shall it profit a man, if he shall gain the whole world but lose his own phone?"

Maybe try: Save the seat with your new iPhone, and don't lock your bike sometimes. **Leave it there.** Go get a coffee. Buy some beer. Everything will be there when you get back. Or not. And if not? It's a very good way to live. **You will be happy ninety-nine times and sad just once.**

I WAS going To FRance to live for ever.

A Royal Flagship La Premiere Diamond Imperial Forbidden Pavilion Supreme Extra Special Luxury First Class Crime

My father offered to drive me to the airport. I had packed my new clothes, my new portfolio, pretty much everything I owned. We loaded up the car and went around the corner for a quick coffee. When we came back, of course everything was gone. I still had my (economy) plane ticket, a credit card, and my passport, so we hightailed it to JFK Airport.

As soon as I boarded the plane, I plopped right down in first class and guzzled Champagne (another grand mistake) until we arrived at Charles de Gaulle. So there I was, in France with *rien du tout*. A *tabula rasa*. It was fun to buy new *caleçon* and a *nouveau brosse à dents*. Then I bought all these weird clothes at thrift shops, the

kind I'd normally never wear. I felt kind of lightheaded and ended up in Rotterdam, falling madly in love with three Dutch guys who worked together. Because I didn't have my stuff, I didn't have to be "me" anymore.

I'm glad my father and I went for that coffee. A recipe for disaster freed me from myself. *Cette recette pour un désastre m'a libéré de moi.* Without that disoriented, lightheaded feeling of losing everything, I never would have felt that free.

I've upgraded my bad self several times since. Swissair's service is the best. Once, I got caught, and it was a huge embarrassment.

Amortizing once out of perhaps twenty-five times, the humiliation was well worth it. I love getting away with things, and, after all … who is it hurting? *Salut!* Cheers!

What, me worry?

I practice this same principle when the subject of Internet security and cell phone GPS tracking and Facebook knowing who you vote for comes up. I think it's dreadful, but my involvement ends there. *If you spend your life worrying about Big Brother, Big Brother has won.* I don't care who knows what I'm up to. At least I'm busy being up to … something fun.

Après moi, le déluge.

If I devote my creative energy to fearing the inevitability of the Russians tampering with our democracy, it just saps my soul. I hope that someone will fight the good fight, maybe the next generations can save us. But I'm cynical. I figure, at age sixty-six, I'm already doomed. If I have ten or twenty years left on this corrupt and blighted planet, I'm going to spend them drawing, painting, cracking jokes, and wearing miniskirts in winter.

I like my coffee with half and half. Every morning I take my cholesterol medication with that. Here's to modern medicine. If I die a tiny bit sooner, so be it. Aaaaah. Delicious!

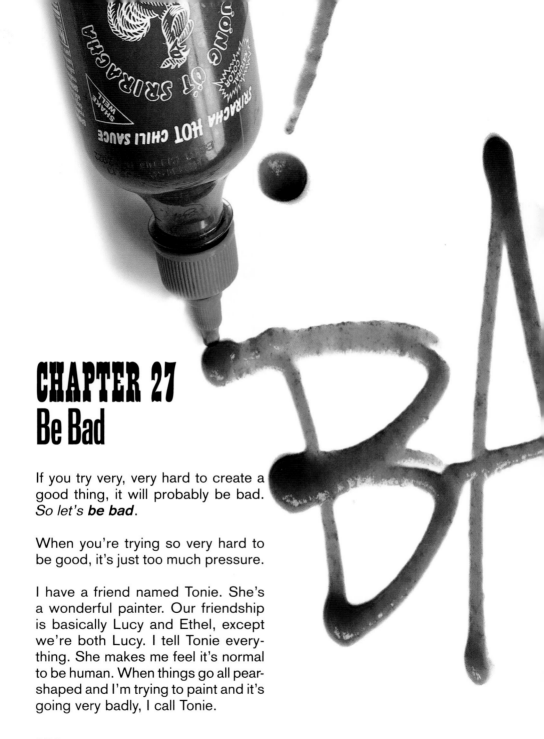

CHAPTER 27
Be Bad

If you try very, very hard to create a good thing, it will probably be bad. *So let's **be bad***.

When you're trying so very hard to be good, it's just too much pressure.

I have a friend named Tonie. She's a wonderful painter. Our friendship is basically Lucy and Ethel, except we're both Lucy. I tell Tonie everything. She makes me feel it's normal to be human. When things go all pear-shaped and I'm trying to paint and it's going very badly, I call Tonie.

I will always remember her sage advice: **"Well—you can always paint bad!"**

PAINT BAD COOK BAD SING BAD WRITE BAD JOKE BAD WORK BAD PLAY BAD BE BAD

Tonie's latest painting seems to be a floral tribute to a couple of kangaroos. And it's really, really good.

Too Late to Die Young Now!

For Friendship That Is My Family:
Nancy Kintisch, Risa Mickenberg, Alexander Sorokin,
Tonie Roos, Babyface, Lisa Rosen, Brenda Meredith,
Kirsten Johnson, Betsy Newberry, Georgia Gunn,
Jane Nisselson, Gina Roose, David Ray, Stefan Rosén, Tove,
Bruno and Lene Due, Lena Kristiansson, Michele Collins,
Elias Werne, and especially Anders Wenngren, Best Mistake Ever.

For Being Bookish:
Karina Eckmeier, Paul Bresnick, Lauren Marino, Michael Gerber,
Michael Rosen, Jill Davis, Cyrus Highsmith, Kurt Andersen,
and especially Norman Hathaway who worked with me on an early version
of this book.

Thanks Also To:
The New York Society Library, Konstepidemin, Annaghmakerrig,
and The London Library.

I run on mostly vitriol, Chobani Coconut yogurt, and outrage.

I lost my virginity in Central Park. I have a crush on Matt Berry. I pretend I'm
not bothered, but I'm jealous of everybody. Also, I only wear a bra on
special occasions, which is reprehensible.

Those are not acknowledgments, Laurie. Those are admissions.

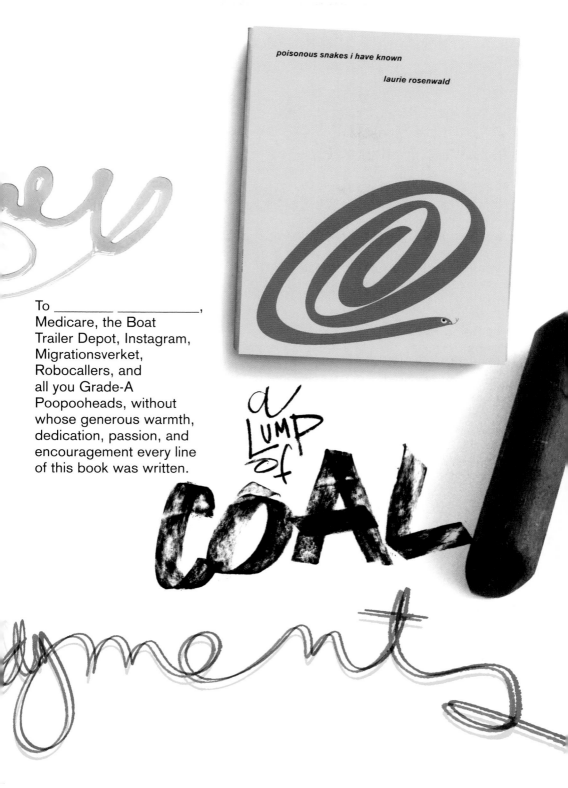

poisonous snakes i have known

laurie rosenwald

To _____ _____,
Medicare, the Boat
Trailer Depot, Instagram,
Migrationsverket,
Robocallers, and
all you Grade-A
Poopooheads, without
whose generous warmth,
dedication, passion, and
encouragement every line
of this book was written.

a LUMP of COAL

MY PLAT FORMS

Robert Rosenwald, 1969

Workshop: http://www.mistakesonpurpose.com
Instagram: http://www.instagram.com/rosenworld
Twitter: @rosenworld
Web: http://www.rosenworld.com
Painting: http://www.laurierosenwald.com
Writing: http://medium.com/@rosenworld
Book: https://www.hachettebookgroup.com/contributor/laurie-rosenwald

Top Floor, Ego Department!

Laurie Rosenwald is principal of rosenworld, a design studio. She also does humor writing, as well as writing that is only marginally funny.

Actually, there is no studio. Rosenwald works alone, and rosenworld doesn't exist. In spite of this, rosenworld.com was launched in 1995. She's done hundreds of drawings for *The New Yorker*.

She invented an incredibly popular workshop called "How to Make Mistakes on Purpose," which she holds for entities like Google, IKEA, TEDx, *Studio 360*, Scholastic, Johnson & Johnson, Artek, Adobe, Starbucks, and a herd of elk. It is not a creativity workshop. Trying to be creative works about as well as trying to be charming. Anybody can do it, and it's just plain fun.

Her design, illustration, and animation clients include Fiorucci, Bloomingdale's, Barneys, Target, IKEA, *New York* magazine, *The Atlantic*, *Harper's*, Shiseido, Chronicle, Knopf, Hachette, Ogilvy, JWT, Mother, Pentagram, Coca-Cola, *The New York Times*, *Vogue*, *Paper* magazine, Houghton Mifflin, Sundance TV, Virgin, the Whitney Museum of American Art, the Jewish Museum London, Warner Brothers, Dentsu, BBDO, Sony, Nickelodeon, and *WET: The Magazine of Gourmet Bathing*.

Rosenwald is a frequent contributor to *The American Bystander*. One piece is titled "Enormous Blonde Herring-Scented Nauseatingly Fair-Minded Nymphomaniacs in Clogs." She has performed at many storytelling events, and her writing has been included in many collections including *101 Damnations* and *The Mirth of a Nation*.

She paints in hot wax, a.k.a. encaustic, a sadly misunderstood medium, much misused by hobbyists and housewives, or anyone who enjoys the smell of burning flesh. Her paintings have been featured in many solo and group exhibitions, including Spring Break 2020, Chashama, Konstepidemin, and Galerie Pixi, Paris.

Rosenwald appeared in the pivotal role of "Woman" on *The Sopranos*, a role she was born to play. She speaks Swedish like a native New Yorker, has never used an emoji, and claims to have won all the usual awards.

Memwah, an illustrated memoir, is in the works.

It wasn't that I didn't believe in God, I was just too arrogant to ask for help.
—Clarissa Theresa Philomena Aileen Mary Josephine Agnes Elsie Trilby
Louise Esmerelda Dickson Wright